DESIGNER'S
GUIDE TO
MARKETING

BETSY NEWBERRY

NORTH LIGHT BOOKS
CINCINNATI, OHIO

This hardcover edition of *Designer's Guide to Marketing* features a "self-jacket" that eliminates the need for a separate dust jacket. It provides sturdy protection for your book while it saves paper, trees and energy.

Other fine North Light Books are available from your local bookstore, art supply store or direct from the publisher.

01 00 99 98 97 5 4 3 2 1

LIBRARY OF CONGRESS CATALOGING IN PUBLICATION DATA

Newberry, Betsy
 Designer's guide to marketing / by Betsy Newberry. — 1st ed.
 p. cm.
 Includes bibliographical references and index.
 ISBN 0-89134-809-3 (hardcover)
 1. Commercial art—United States—Marketing. I. Title.
NC998.5.A1N488 1997
741.6'068.8—dc21 97-11259
 CIP

Edited by Terri Boemker
Production edited by Marilyn Daiker
Designed by Angela Lennert Wilcox
Cover photography by Brian Steege, Guildhaus Photographics

The permissions on page 142 constitute an extension of this copyright page.

METRIC CONVERSION CHART

TO CONVERT	TO	MULTIPLY BY
Inches	Centimeters	2.54
Centimeters	Inches	0.4
Feet	Centimeters	30.5
Centimeters	Feet	0.03
Yards	Meters	0.9
Meters	Yards	1.1
Sq. Inches	Sq. Centimeters	6.45
Sq. Centimeters	Sq. Inches	0.16
Sq. Feet	Sq. Meters	0.09
Sq. Meters	Sq. Feet	10.8
Sq. Yards	Sq. Meters	0.8
Sq. Meters	Sq. Yards	1.2
Pounds	Kilograms	0.45
Kilograms	Pounds	2.2
Ounces	Grams	28.4
Grams	Ounces	0.04

To my niece Samantha Pisciotta.
I hope that New Orleans palm reader is right.

A significant portion of this book was researched and written by my husband, Jon Newberry. Jon has been writing for the business press for fifteen years and has taught me a lot about business operations and strategy in general. He has a talent for breaking down complex concepts into their most basic elements and then presenting them in commonsense terms—like you wish they would have been presented in the first place.

I'd also like to thank my editors, Lynn Haller and Terri Boemker, for their confidence and willingness to let me develop and write this book in a style and on a schedule determined largely by me; the designer, Angela Wilcox, and the production editor, Marilyn Daiker, for their expertise in bringing this book to its final form.

ABOUT THE AUTHOR

Betsy Newberry is a Cincinnati-based writer specializing in business and design topics. She is the author of *Fresh Ideas in Promotion 2*, is a frequent contributor to *HOW* magazine, and has also covered design for *Visual Merchandising & Store Design* magazine, *Restaurant & Hotel Design* magazine and *Dream Home* magazine. She has authored and edited a number of books on business management and computer training, and has been a regular contributor to numerous regional and nationally distributed business and finance publications.

TABLE OF CONTENTS

Supply and Demand

As consumer communication venues broaden and competition for consumer dollars and loyalty intensifies, graphic designers can no longer rely on creativity and intuition alone to produce successful printed materials and digital presentations for their clients. Intelligent and informed design are what companies are looking for today. And that level of design requires a working knowledge of marketing principles and strategies, and a solid understanding of marketing research tools and techniques.

In researching this book, we talked with scores of graphic designers and marketing strategists. They all agreed that the line between marketing and design functions is becoming more and more blurred. Not too long ago, a company would develop a product, establish the pricing and distribution channels for it, and organize a promotion campaign. The graphic designer was generally only involved in the promotion phase of the marketing cycle, and they were more or less told what and how to design. But now, companies are looking to graphic designers to provide them with the solutions that will help them communicate with their target markets.

Good Design Is No Longer Enough

As one designer said, "Research of a client and its target market and an understanding of what the client wants to accomplish makes design responsible, not just aesthetic. We find that when we combine our knowledge with our design, we become a very potent resource for our clients. Our ability to effectively use this knowledge has helped us win a substantial amount of business when our design skills might be the same as other competing firms."

A marketing executive for The Disney Store echoes that sentiment: "In the realm of marketing, the earlier design is involved, the better off you are. Marketing people are partnering with designers in the early stages of a project. It's not enough to be a great designer anymore. You really have to be able to contribute marketing insight."

The purpose of this book is to provide an overview of the theory and practice of marketing for graphic design professionals. It will familiarize them with the ways various marketing concepts are applied by their clients, and it will enable graphic design professionals to incorporate knowledge of marketing and marketing techniques more easily into their design practices. The goal is to give graphic designers something of a competitive edge, or to at least remove what could otherwise be a substantial competitive disadvantage.

Competition Is Increasing

Design firms increasingly are competing head-on with much larger marketing, advertising and public relations firms that are incorporating design services into their businesses—either as in-house services or by subcontracting design functions with specialist firms who work for them rather than directly for the ultimate client.

Design practitioners, therefore, who are not comfortable working with marketing concepts may often find themselves at a disadvantage either working with marketing firms or competing against them for business. The subject matter covered in this book will give designers a background in marketing concepts and their common applications in today's business world, so that they can meet professional challenges with confidence.

While this book is not intended to serve as a detailed handbook for a marketing professional, it does give nonmarketing professionals a solid overview of the subject so they can be conversant with marketing practitioners. It will familiarize them with marketing topics they encounter in the course of their business and give them an ability to recognize areas in which they may need further, more detailed knowledge and help them know where to look for it.

How to Use This Book

This book is organized into two sections. The first provides a comprehensive overview of marketing principles and concepts. Throughout the text, key marketing concepts are italicized at first mention for easy identification and are included in a glossary of terms at the end of the book. Also note that, in order to make the text more readable, references throughout the book are made to "products," although in most cases they also apply as well to services or ideas or anything else that is the subject of marketing activities.

The second part presents a series of case studies on successful design projects in which the design studio was actively involved in the marketing effort for a product or service. A full-color gallery showcasing other projects in which designers applied a certain level of marketing skill and savvy accompanies each case study. A list of resources and additional reading is also included at the back of the book.

Marketing Principles for Graphic Designers

THE DEVELOPMENT OF MARKETING

Some say marketing is a science, others say it's a theory, and still others say it's plain common sense. We'll go out on a limb and say it's a bit of all three.

THE BEGINNINGS OF MODERN MARKETING

Marketing in its modern sense has its roots in the Industrial Revolution. The second half of the nineteenth century was characterized by a dramatic leap in industrial production technology, the beginnings of mass production techniques and the development of efficient means of transportation to get goods from sellers to buyers. As a result of technological improvements and rising living standards, prices were much more affordable for many goods that had previously been unavailable to most people. This stimulated a growing *consumer* demand, and manufacturers seemingly could sell at a reasonable profit everything they produced.

By the 1920s, enhanced production capabilities caught up with and surpassed consumer demand for many products. This prompted more manufacturers to try to stimulate demand for their products with mass-market advertising and hard-sell techniques. This era of sales and advertising was the beginning of modern marketing, but it was a very primitive form of marketing compared to the more sophisticated marketing practices that began to take hold in the 1950s. Many companies, however, are still stuck in the sales-and-advertising phase even today.

The era of widespread, sophisticated marketing as we now know it began in earnest after World War II, as manufacturing capacity shifted out of weapons and armaments and into the production of consumer goods. As modern manufacturing technologies found new con-sumer and commercial applications, production capacity exploded. It became increasingly apparent to businesses that it made sense to determine more precisely what consumers wanted and what they would pay for before going to all the trouble of developing and making the products.

CONSUMER-DRIVEN MARKETING

Thus unfolded the true age of marketing, in which the desires of *customers* and end-users drives business decision making rather than mere production capabilities.

Marketers sometimes refer to this customer-oriented approach as *outside-in*, in contrast to previous approaches that were essentially *inside-out* in that they were driven by what the company itself had the capacity to make or desired to sell. As a result, we not only have competing *brands* of athletic shoes, cars, beer, office equipment or whatever, but we now have arrays of products, packages and families of brands from the same company, each variation intended to satisfy the specific desires of a small market niche.

MARKETING TODAY: A FASTER PACE THAN EVER BEFORE

Recent advances in data collection and digital communications technology are compressing *product life cycles* and revolutionizing marketing practices. The computerization of industry, particularly of *wholesale* and retail distribution channels, and the spread of personal communications devices allow marketers to have, in many cases, almost instantaneous data on product movements and unheard of detail on targeted consumers' buying

habits. Where marketing professionals used to rely heavily on year-long market tests, for example, to gauge the likelihood of a new product's success, they now more often use simulations to project marketplace acceptance in a much shorter time frame. Where it previously took weeks or months to judge the effectiveness of an advertising campaign, and even then with no clear way to determine cause and effect, marketing data can now pinpoint buyers' reaction as well as motivations overnight.

All of these developments have led to a shrinking of the time gap between research, product development and product introductions. Marketers can no longer conceive a product based on research of the past, develop it for today's consumers and then try to sell it tomorrow. The entire cycle is being compressed so that consumers can have what they want, when they want it—even as they change their minds, their tastes and their lifestyles. Marketing has become a two-way process of projection, feedback and response.

A Technology-Driven Marketing Revolution

As A.B. Blankenship and George Edward Breen write in their book, *State of the Art Marketing Research:* "While the 1970s and 1980s saw advances and improvements in research methods, the phenomenal growth of electronic technologies in the late 1980s and early 1990s can do more than just change methods; these technologies can revolutionize the whole field of marketing.

"New methods allow us not only to find out more about consumer attitudes, behaviors and desires today, but to predict who tomorrow's consumers will be, what products and services they want, and how they will want to buy them."

How Today's Technology Is Changing Marketing Research

Blankenship and Breen detail some of the new applications of computer technology to marketing research and data collection, including:

• The ability to correlate demographic and geographic market data with sales trends and promotional efforts using inexpensive desktop computer systems.

• The spread of electronic *scanners* from retailers to manufacturers and their integration into the entire distribution process.

• The emergence of *single-source data* technology, a form of data collection that links buying behavior directly with consumer attitudes and exposure to various promotions.

• Use of point-of-sale computers to continuously adjust inventories and stock on store shelves.

• Development of commercial *database* services that compile lists of potential customers using information from credit card companies, magazine and catalog subscribers and hundreds of other sources.

Further advances in technology and better adaptation of existing technologies into the marketplace—such as the use of debit cards and the wealth of customer-specific information that could flow from such uses—will certainly continue as new product introductions increase in frequency and marketers demand even more detailed and timelier information about the markets they are trying to serve.

THE DIGITAL REVOLUTION

In *The Marketing Information Revolution*, the authors maintain that while marketing has always been a function of information and information processing, a revolution has occurred in the past decade, triggered by "a qualitative change in the capacity to collect, store, process and transmit information." They credit this revolution to technological advances in computing and telecommunications.

The adoption of telecommunications and computer technology has resulted in dramatic increases in both the speed with which information is transmitted and in the amount of information that can be stored and processed in a given unit of time. These increases in transmission speed and processing capacity allow for creating new types of information that form the heart of the revolution.

2

COMPONENTS OF MARKETING

Marketing can be defined as any human activity that's intended to create demand for some product or service. As a general description, that's probably as good as any, although in many ways marketing encompasses a much broader range of processes. The subject of marketing doesn't have to be a product or service, it can also be a place, as in promoting tourism, or even an idea—curbing drinking and driving. Moreover, the goal of marketing isn't always to increase or even maintain demand. Antismoking and antiabortion groups, to cite only two examples, engage in large and very sophisticated marketing efforts intended to *decrease* demand for certain products and services.

MARKETING IS MUCH MORE THAN SELLING

Marketing activities include those designed to generate demand (or negative demand)—advertising, promotion, selling, pricing, product development—as well as those intended to satisfy demand—distribution, transportation, order processing, delivery and handling. In an even broader sense, particularly as modern business practices are integrated into one continuous cycle, marketing may even include manufacturing functions.

As a support function for all of these processes, marketing also includes research and information gathering activities—*marketing research* and the operation of *marketing information systems*—intended to inform marketers about conditions in the market, and conditions affecting demand for, as well as the supply of, their products, their competitors' products and possible substitutes.

Marketing often is popularly but erroneously equated with sales or selling, but selling is only one aspect, albeit often a crucial one, of the marketing process. Moreover, the emphasis in effective selling, which tends to be product-oriented (inside-out), is often quite different than the customer-oriented (outside-in) emphasis needed to accomplish other marketing objectives. For that reason, an overreliance on selling to the neglect of other aspects of marketing can be a costly mistake.

HOW A GOOD MARKETING EXECUTIVE THINKS

Marketing expert Philip Kotler said that sales executives tend to think in terms of sales volume rather than *profits*, short run rather than long run, individual customers rather than market segments, and field work rather than desk work. Good marketing executives, by contrast, think in terms of sales as a function of profit planning; long-run trends and opportunities; differences between customer types and market segments; and market analysis, planning and control systems.

Paul Sherlock maintains in *Rethinking Business to Business Marketing* that entrepreneurial spirit is a key element of effective marketing, whether the product is produced by a Fortune 500 powerhouse or a struggling inventor. He contrasts driven entrepreneurs with bureaucrats for whom control and procedure are paramount: "... the spirit of entrepreneurship is in the region of magic, not quantifiable science. However, the final test of entrepreneurship *is* quantifiable. Is the venture successful?"

YOU HAVE TO GIVE PEOPLE WHAT THEY WANT

Since goods and services are generally not in short supply, successful businesses no longer succeed merely by

producing a better mousetrap. Buyers aren't in the habit of beating paths to anyone's door—the path-beating is almost always in the opposite direction. Businesses have to produce a product that people genuinely want (or can be stimulated into wanting), must be able to sell it for the right price and have it where people want it, when they want it.

That's what marketing is all about and what drives successful businesses. A designer may be very good at a particular medium or style, but to succeed, those talents must be molded into a product or service that specific clients want, know about and are eager to pay for.

The Marketing Mix

According to Robert Bartels in *The History of Marketing Thought*, the *marketing mix* is "the combination of means for achieving the marketing objective of a business firm, which are blended in varying proportions by management in consideration of prevailing circumstances. The 'elements' of the mix include all promotional means under the authority of the manager of marketing activities: personal selling, advertising, credit service, product development, packaging, dealer relations, etc."

Academics and marketing practitioners traditionally have viewed the marketing activities applied to a particular product as comprising four principal elements. They refer to them variously as the marketing mix or sometimes as the *four Ps: product, price, promotion* and *distribution* (or "place" for the fourth P).

Product

Broadly speaking, product refers to actual physical goods or services, ideas or locales—whatever it is that marketers are delivering to satisfy supposed consumer needs. Important attributes of products include their brand names, trademarks and packaging.

Products typically have *life cycles* common to similar products, each stage of which demands a somewhat different marketing emphasis. A life cycle generally runs from introduction followed by a growth or expansion phase then through a mature phase and later to decline and eventual death. Some well-entrenched products—Coca-Cola comes to mind—seem to defy life cycles altogether and go on forever. That's often just a sign of good marketing.

The task of marketing in some cases is to stretch out life cycles as long as possible, or better yet, reverse them and take a product that is mature or in decline, reinvigorate it and snap it back into another growth phase. In other cases, marketing focuses on squeezing as much volume and profits as possible out of a product before it goes into irreversible decline. The trick for marketing managers is figuring out when to invest in order to get more out of a product or, conversely, when to pull the plug.

The length of life cycles tends to vary with categories of products and services. Movies, for example, used to have brief, well-defined life cycles of a few weeks to several months in first-run theaters, then maybe a few more months in second-run neighborhood

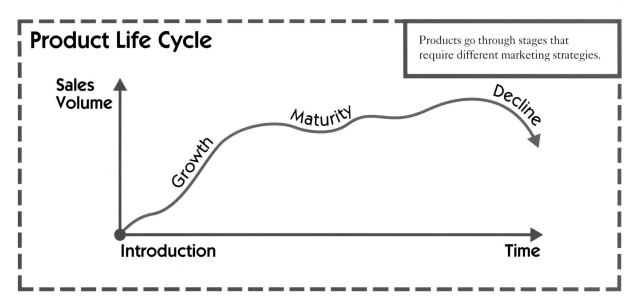

Product Life Cycle

Products go through stages that require different marketing strategies.

theaters and drive-ins. With the growth of video rentals, movie life cycles have been extended substantially, although most are regarded as being in decline by the time they're released on video. High-fashion and trendy clothes are another class of products that have very short life cycles, so designers and manufacturers have come to depend on introducing new fashions every season.

By contrast, some mature food products have life cycles that can go on and on for decades. They are characterized by strong brand names and high-quality reputations—Chiquita bananas, Quaker Oats, Morton salt, to name a few.

WHY MARKETING STRATEGIES WILL CHANGE OVER TIME

Marketing strategies can be largely determined by which stage of a life cycle a product is in. When something is just introduced, it can require a lot of promotion and advertising just to get the word out and make information about it known to the public. Once a beachhead is established and it begins gaining momentum, distribution becomes critical as there is a window of opportunity to establish relationships with dealers or *retail* outlets and expand into complementary market segments. Maturity requires close attention to shifts in the market to maintain as much momentum as possible. Also important is a continual search for fresh markets, new applications and/or product refinements. Once products are in decline, they either need to be reinvigorated through redesign or repositioning, if possible, or costs have to be trimmed to a minimum to extend profitability as long as possible. If decline is irreversible and profitability erodes, at some point the decision has to be made to discontinue it and invest whatever resources are salvageable into a better prospect.

PRICE

Price includes everything that a buyer pays to a seller for a product or service. In simple terms, it may be only cash, but marketers also have to consider any additional terms of a sales contract, the extension of credit, quantity discounts, incentives, specials, couponing and even noncash mediums of exchange.

Price determines how much potential profit a business can make selling a product. It is subject to what economists call *elasticity of demand*, which is a measure of how much consumer demand for a product rises or falls as the price changes. If demand is inelastic, producers can safely raise prices with relatively little decrease in the number of sales. On the other hand, if prices are highly elastic, lowering the price can result in significant increases in the number of sales and, in some cases, higher profits. Elasticity typically varies depending on the price level, the supply of similar products or viable substitutes and the nature of the product and its marketing mix.

A drug that cures a deadly disease will have a certain number of buyers at almost any price if it's the only cure available. Below a certain level, cutting the price would have no effect on demand. That's why prices for new drugs tend to be high. On the other hand, when producers face lots of competition, such as farmers during a season of bumper crops, prices for their products tend to be highly elastic. If they try to charge too much, they'd have no buyers at all.

HOW PRICES ARE DETERMINED

Determining what price to charge for a product isn't always as straightforward as it might seem. It depends on what the seller's objective is, and going after "the highest profits possible" doesn't really provide an answer. It just raises additional questions: Highest profits over what period of time? And when does a higher price quit translating into higher profits, i.e., when does a higher price mean too few sales?

Product costs are usually at their highest when a product is introduced, which also happens to coincide with the period when demand is generally lowest—nonexistent, at least until the word gets out. So shooting for high immediate profits from a new product may doom it to failure before it ever has a chance. More often, a marketer has to accept a period of losses until he or she can either generate sufficient sales volume to begin turning a profit or sustain an increase in price by building demand.

Once a product has been successfully introduced, the time horizon shifts but is still a critical factor. Much depends on the length of the product's expected life cycle. A breakthrough technological product that can

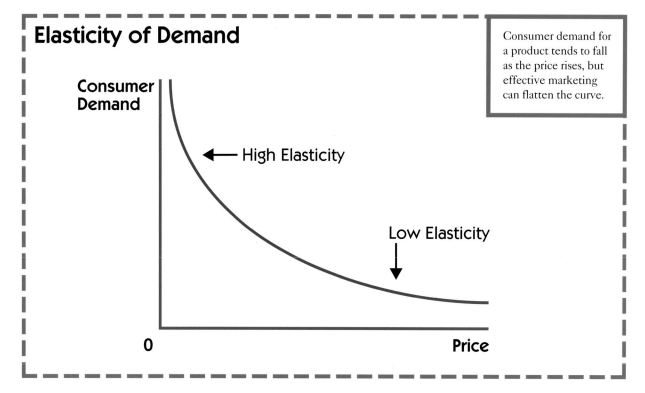

Elasticity of Demand

Consumer demand for a product tends to fall as the price rises, but effective marketing can flatten the curve.

give businesses a big jump on their competitors may be priced with a goal of garnering as much profit as possible, on the assumption that it will be superseded in a year or so, at which point profit margins will have to be cut. On the other hand, an aggressive retail chain trying to expand into new markets may adopt a pricing policy intended to generate only a minimum profit on each dollar of sales, hoping to build a loyal base of customers who will stick with it for generations.

Products that have reached maturity or are in decline often have to absorb steep price cuts to fend off new competitors who, paradoxically, might have been attracted by that product's very success.

NINE PRICING STRATEGIES

In *Cases in Marketing Management*, the authors describe a series of pricing strategies:

• *Mark-up pricing:* Price is based on cost plus a standard percentage, regardless of other factors such as consumer demand. The advantage is that it makes individual pricing decisions easy when there are too many products to analyze thoroughly and effectively. It's common among retailers.

• *Break-even pricing:* Price is based on what's needed to offset costs, assuming a projected unit volume is achieved. Any sales above that level would generate profit.

• *Rate-of-return pricing:* This is most often used by large businesses that are dominant in their industries with a stable customer base. Prices are determined by the amount of profit needed to achieve a certain return on its investment.

• *Variable-cost pricing:* This scheme is used selectively in industries with high ratios of *fixed costs* to *variable costs*—airlines and hotels, for example. The idea is that they can make more money by charging certain classes of customers lower prices, as long as they are high enough to recoup the variable costs and contribute at least something toward the fixed costs that the business has to incur anyway.

• *Peak-load pricing:* Prices are differentiated between peak and nonpeak periods to encourage customers to use services more when demand is slack. This is often employed by utilities to hold down demand that might otherwise exceed capacity, reducing the need to invest in additional facilities.

• *Value-in-use pricing:* Prices are set based on the benefit specific customers derive from the product or service. It's most often used with customized products or services.

• *Skimming price:* Used for advanced new products, prices are set to reap larger profits initially from buyers who want the latest technology, then they are lowered

over time to win less-eager consumers who can afford to delay their purchases until prices moderate. This strategy is often used today by makers of computers and accessories.

• *Penetration price:* Price is set below costs to entice customers into using a product and thereby increase sales volume in mass markets. It's often employed by new entrants into established markets to offset advantages of the market leaders.

• *Negotiated price:* Many big-ticket items, consumer goods as well as business equipment, are listed for sale at a higher price than dealers are willing to sell. The list price provides something of a starting point, the intent being to get the buyer to make a reasonable offer at some lower price and then negotiate toward a mutually acceptable final price.

PLACE

Place refers to the distribution channels a marketer employs to get a product to its customers. While the word "place" evokes images of warehouses and retail outlets through which products are physically moved until they are placed in the hands of customers, in a marketing sense it can mean any type of distribution channel (these days, even the Internet) as well as components of that distribution channel that have nothing to do with buildings or sites.

Of primary importance is the kind of sales force that will be employed: inside sales people, independent sales reps, commissioned sales agents, dealers or distributors with exclusive territories, franchisees, mass-market retailers or combinations of these.

Sales and distribution organizations tend to follow similar patterns within industries, partly because of tradition and inertia, partly because there are functional justifications for them. Frequently, however, a marketer will adopt a different technique than the rest of the industry and thereby acquire a competitive advantage. Avon Products and Amway, for example, have sold consumer package goods through network-based sales organizations for years, bypassing store-based competition and avoiding the high fixed costs associated with normal retail trade.

Sometimes two or more modes of distribution coexist within an industry. Restaurants are a good example. Prior to and immediately after World War II, almost all restaurants were individually owned by local operators. Then franchised restaurant chains such as

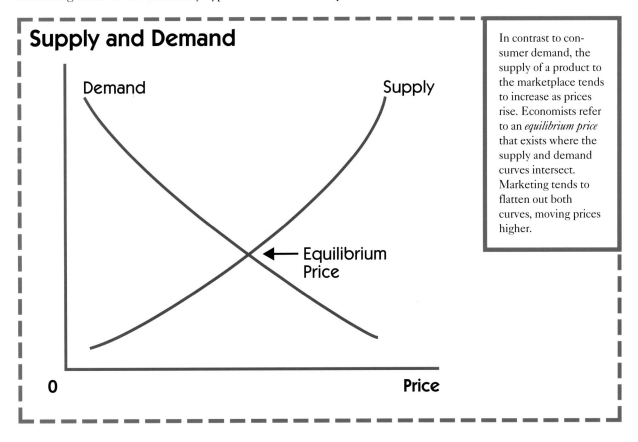

Supply and Demand

Demand

Supply

Equilibrium Price

0

Price

In contrast to consumer demand, the supply of a product to the marketplace tends to increase as prices rise. Economists refer to an *equilibrium price* that exists where the supply and demand curves intersect. Marketing tends to flatten out both curves, moving prices higher.

Big Boy and McDonald's began to emerge, first regionally, then nationally. In many cases, restaurants were franchises of a large organization and franchisees operated clusters of restaurants within a protected territory. *Franchising* allows chains to expand rapidly by attracting outside capital and dedicated local managers—through the franchisees—yet limit financial risk while keeping control of a national revenue stream. Today the restaurant industry contains a mix of organizational styles— local independents still dominate the fine-dining end of the market, while company-owned chains and franchised chains dominate the casual-dining and fast-food segments.

PROMOTION

Promotion refers to all of the various methods and tools that marketers use to spread the word about their products and encourage consumers to buy it. These are detailed in chapter eleven, but they include personal selling, advertising in all its forms, public relations, publicity, point-of-purchase displays, trade shows, direct mail, coupons, networking, public speaking and sponsorships.

3

MARKETING RESEARCH FUNDAMENTALS

Marketing research is the process of identifying, collecting and analyzing information about what consumers, customers and the public are doing in the marketplace, why they're doing it, what they want, what their needs are, what they'll pay, how they can best be reached and how they make their buying decisions. In short, marketing research is the means by which marketers obtain the information they need to make decisions.

THE VALUE OF MARKETING RESEARCH

Businesses and other organizations use the information they derive from marketing research to forecast trends, fine-tune existing products, develop new ones and evaluate the effectiveness of their marketing practices.

For example, if the Baby Boom Bike Co. surveys bike shop patrons and discovers that people over forty are more likely to buy bikes with fenders and heavily padded seats, it may want to gear up its manufacturing capacity to produce more of them and also alert its salespeople and dealers. If surveys show that recreational bike riders' biggest complaint is the difficulty of climbing hills, it might develop a bike with a super-low gear coupled with retractable training wheels that drop down for crawling up inclines at a snail's pace. Or it could consider an electric motorized assist that automatically activates when a moving bike is pointed up a steep hill.

If bike buyers' responses to questionnaires indicate that few of them recall having seen its Baby Boom Bike Bowl (a TV commercial extravaganza pitting opposing teams of beer bottles mounted on bicycles in an animated football game) during the Super Bowl half-time show, and that virtually every one of them was instead out riding a bike at the time, the company might want to cancel its advertising plans for the next Super Bowl and switch the money into billboards or a direct-mail campaign instead.

DATA, INFORMATION AND INTELLIGENCE

Marketing research yields several levels of output that businesses may find valuable. At its most elementary level, research yields raw data is not very helpful except that it provides the basis for useful information when organized or combined with other data.

If Minivan Motorcar Co. conducted a nationwide telephone survey of American households, it would produce all kinds of *data*—individual responses to questions, such as the fact that a certain Jack Droptop in Economowoc, Wisconsin, owns a 1963 Ford Falcon convertible that he drives approximately 15,000 miles a year. It would enter that data into a large database along with lots of other data. Once all of the data is gathered in one place, useful *information* about the marketplace can be derived from it: On average, you might find that each Midwest household would own maybe 2.3 cars, trucks and vans (including Jack's Falcon), each of which they drive maybe 12,535 miles per year. Perhaps 10.4 percent of the households had bought a car in the past year. Maybe 19.9 percent said they planned to buy one in the coming year, and half of them also said they would consider buying a minivan.

That information derived from marketing research could then be analyzed in light of the company's objectives and resources to derive *intelligence* from which achievable marketing objectives are formed.

A STEP-BY-STEP PROCESS

Marketing experts regard marketing research as encompassing a series of steps:

1. *Define the problem.* Define the issue or problem in detail as it relates to the elements of a marketing mix—product, price, place and promotion. If the problem is determining how to reverse a decline in a product's *market share,* for example, all of the elements need to be considered. Should new products be introduced or older products be revamped? What effect might changes in pricing have? Are current distribution methods adequate? How effective have promotional activities been?

2. *Develop hypotheses.* Develop hypotheses, determine what information is needed to test them and explore how that information might be obtained. Can adequate information be derived from in-house data by company personnel? Will it require surveying of potential buyers or competitive products by an outside research firm?

3. *Define your research objectives.* Define marketing research objectives in terms of the marketing problem to be resolved. Then devise a marketing research plan, specifying how data is to be gathered and by whom, questions to be asked, types of analysis to be conducted, time constraints and estimated costs. Various information-gathering techniques might be appropriate. *Focus groups*—five to ten carefully selected people guided by a trained moderator—are commonly used to evaluate the qualitative merit of initial concepts. *Consumer panels* often test product performance or marketing effectiveness over time. Quantitative *surveys*—using either questionnaires, interviewing or various means of direct observation—typically are employed to gauge market acceptance.

GETTING A HANDLE ON THE INFORMATION EXPLOSION

Marketing professionals make a distinction between marketing research, which usually refers to problem-specific and goal-oriented projects, and are called marketing information systems, which are databases and support systems designed to provide decision makers with standardized information about ongoing marketing matters.

Marketing information systems really began to gain popularity in the past few decades as the amount of marketplace information exploded with the application of computer technology to business operations and the increased use of bar codes. Systems had to be developed if for no other reason than that there was suddenly more information than anyone otherwise knew what to do with.

Sources of data for marketing information systems include internal customer information and data derived from sales orders, industry data from trade groups and news media, information compiled by the company on competitors from various sources, data obtained from commercial database services, as well as data from marketing research projects.

In *Introduction to Marketing*, Marjorie J. Cooper and Charles Madden maintain that marketing information systems are designed to keep managers from making marketing decisions based on inadequate information or mere intuition. They note that while market information is almost always available given enough time and money, most managers don't have time and money to spare.

Effective marketing information systems fill that gap, supplying decision makers with information quickly and at little or no incremental cost in circumstances where more detailed and specific marketing research is not appropriate or not yet justified. In most cases, marketing information systems can supply the preliminary information used to test hypotheses, assess alternatives and justify the investment of time and expense in a marketing research project.

4. *Collect data.* Collect and tabulate the data; pull the information desired from it; analyze the information and draw conclusions. Report findings.

5. *Determine if the problem is solved.* Determine if more research is needed or if the problem is solved. Review the problem or opportunity in light of the findings and decide if more or different research is needed. Develop or revise marketing plans accordingly.

4

MARKETING STATISTICS

arket researchers usually study only a small *sample* of a larger group in order to determine its characteristics, just as a cook determines whether a sauce needs more spices by tasting a spoonful or two. The right sample can reveal all the information a researcher wants to know about a larger population, and it can be obtained at a fraction of the cost of a complete *census*.

In most cases, polling an entire *population* would not only be too costly, it would be impossible given the constraints under which researchers must work. If a manufacturer of jeans tried to ask every American male over the age of sixteen about his tastes and habits, by the time they tracked everyone down and completed the poll, styles and preferences would have changed. Marketers are under terrific pressure to get products to market fast, so research has to be completed ever more quickly. Sampling speeds research and controls costs.

How to Choose an Appropriate Sample

In order to obtain information about a population, researchers first have to carefully define the population they're interested in, then identify a suitable *sampling frame*, or *target population*, from which to choose a representative sample. The sampling frame should be either a compilation of certain units in the population under study or a reasonable substitute for it. For example, if you wanted to ascertain the opinions of women who shop at a certain shopping mall, you might use as a sampling frame all the women who shop there during a typical week. If you chose a week during which a highly publicized traveling exhibit was on display, however, that would be a bad sampling frame because the people who came to the exhibit might not be the same ones who normally shop at the mall.

Probability and Nonprobability Samples

Samples can be divided into two basic types: *probability samples* and *nonprobability samples*. Probability samples are *random samples* in which every unit in a population—every person or household in the United States, or every West Coast restaurant, for example—has an equal chance of being selected. With a probability sample, the accuracy of the results can be guaranteed within a mathematically precise *confidence range* or *margin of error* given a certain *confidence level*. These quantitative measurements are based on the laws of statistics, and the size of the sample has a direct effect on accuracy.

In nonprobability samples, which are used much more often because they're usually more cost effective, certain units within the population have a greater chance of being selected, or certain categories are guaranteed a predetermined weighting in the sample. Nonprobability samples are not random, intentionally so. Because of that, the accuracy of the results is not strictly quantifiable as are the results of random samples. That said, with carefully selected samples, results of nonprobability samples have proven to be highly accurate as well as more cost effective than random samples for most business research.

There are dozens of sampling techniques designed by researchers to elicit the information they need at a reasonable cost. An inescapable practical limitation of sampling is that costs rise roughly in proportion to the size of the sample, yet the accuracy of the results rises proportionately less.

Increasing Sample Size Does Not Give a Proportionate Increase in Accuracy

Statistically, a researcher has to quadruple the size of a random sample in order to cut the margin of error in half. That fact can often make the use of random samples impractical, particularly if researchers want to break the data down into smaller subsamples. For example, if a national political poll surveys about 1,000 people across the country to find out who is favored in an election, the results will be highly reliable—within three percentage points (margin of error) of their true preference—in 19 out of every 20 surveys (95 percent confidence level). But if the researchers want to use the same data to project who is favored in individual states, the reliability is far less because of the reduced sample size. In states where by chance a random sampling of the country polls very few people, the data would be so unreliable as to be all but useless.

Because of this relationship between sample size and reliability, researchers tend to prefer using various nonrandom samples to assure themselves that they get enough of certain units without having to poll an unreasonably large and costly sample. For example, a political polling organization might survey 2,000 people across the country, then survey additional people in key states, until they had a minimum of 100 from each such state to ensure reasonable reliability.

Three Types of Nonrandom Samples

1. *N^{th} name sample:* Pick an arbitrary starting point then go down a list and sample every 10^{th} (or 100^{th}, or $3,457^{th}$) unit. It's easier and more effective than simple random sampling, but researchers have to make sure the interval they choose does not skew the results because of a

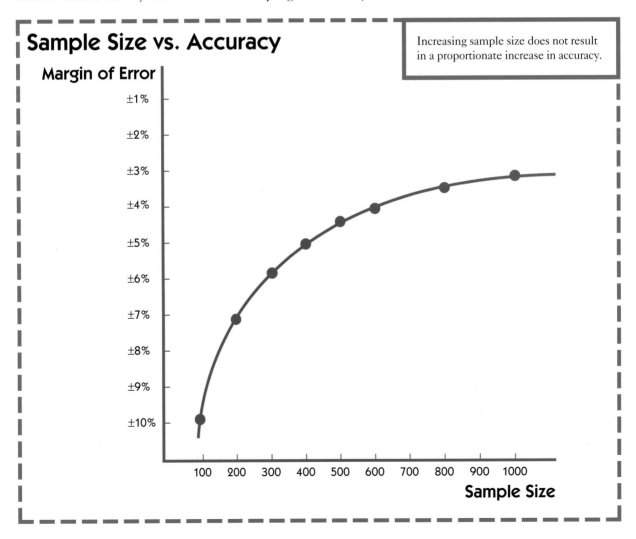

Sample Size vs. Accuracy

Increasing sample size does not result in a proportionate increase in accuracy.

Margin of Error

Sample Size

corresponding cycle in the sampling frame. For example, say a car company decides to disassemble every 5,000th car it makes to check for defects. If it makes 1,000 cars a day, it could end up testing only cars that roll off the assembly line on Monday mornings, which probably wouldn't be a good representation of its overall output.

2. *Convenience sample:* In effect, the selection is usually left up to the interviewers, at a shopping mall, for instance. They can choose anyone that comes along, with no quotas or prequalifications. The results will have a high degree of uncertainty that's generally not statistically measurable, but *convenience sampling* is a cheap and easy technique that can be very useful to get a quick reaction to an idea or concept.

3. *Stratified sample:* The hypothetical polling example cited above is an example of *stratified sampling.* Researchers divide the target population into segments and design a sample that includes a statistically meaningful number from each segment or from specific segments that are to be studied.

Errors and Biases in Sampling

Poor sampling techniques can introduce a number of errors or biases that can skew results. Even pure random samples are subject to an inescapable margin of error, producing what is called a *sampling error.* A random sample of sufficient size can produce a result that's very close to the true population, but there is always some residual possibility of sampling error.

In addition to sampling error, nonsampling errors and biases can further skew results of a survey, including *nonresponse bias*, interviewer bias, lying, inaccurate memory, recording errors, misunderstandings, and so on.

Nonresponse bias occurs when classes of people are not included in a survey and the reasons they are not included are related in some way to the subject matter of the survey. For example, if a local church group decided to conduct a door-to-door survey to determine the religious affiliation of people living in a certain area, it wouldn't want to do it on a weekend. Many of the religious people would be away at church, so the survey would underrepresent them. Likewise, it wouldn't be a good idea to conduct a mail survey of

SAMPLING AND CONFIDENCE

According to the laws of probabilities and statistics, if you want to know the proportion of households that own a computer, drink beer or understand probability theory, and you conduct a large number of random surveys of 1,000 households each, the survey results will be distributed in a bell-shaped curve, known as *bell-curve distribution*, around the true proportion within the population. Most of the surveys will give you an answer very close to the true proportion; only a few will yield results that are way off the mark.

people's attitudes toward junk mail because people who don't read junk mail, and simply throw it away as an unwanted nuisance, would be systematically underrepresented in the results.

Nonresponse bias can also be caused by questionnaires that are too long, subject matter that is not of interest to the respondent, the way in which they are approached and other factors.

A related bias can occur when respondents lie about their attitudes or behavior, possibly because it is perceived as unfavorable, unfashionable or even illegal.

Confidence Intervals in Sampling

Statisticians would say that a random sample of 1,000 households produces a *confidence interval* or confidence range of plus or minus three percentage points with a 95 percent confidence level. The confidence interval or range is what pollsters refer to as a survey's "margin of error."

Now let's put these concepts into more practical terms for a market researcher who is trying to ascertain what the true percentage is. If we surveyed 1,000 households, we could be 95 percent certain that the true percentage in the population falls somewhere within three percentage points, plus or minus, of our survey results.

That level of precision is generally more than adequate for business decisions. If less precision will suffice, a smaller sample size can be used, which can

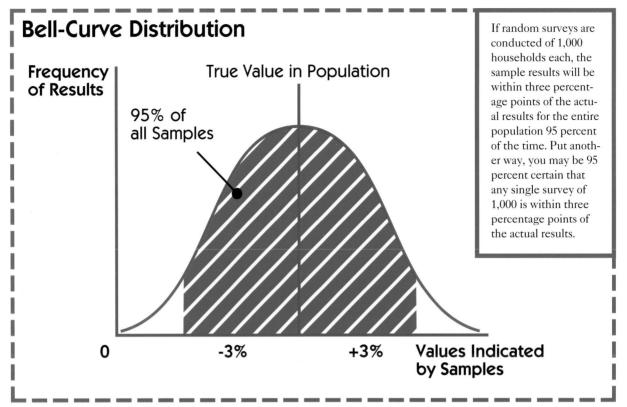

Bell-Curve Distribution

Frequency of Results

True Value in Population

95% of all Samples

If random surveys are conducted of 1,000 households each, the sample results will be within three percentage points of the actual results for the entire population 95 percent of the time. Put another way, you may be 95 percent certain that any single survey of 1,000 is within three percentage points of the actual results.

0 -3% +3% **Values Indicated by Samples**

reduce the cost of the market research significantly. If a confidence level of 90 percent is adequate, for example, the sample size can be cut by 30 percent without affecting the margin of error.

If a margin of error of plus or minus 6 percentage points is OK, then the sample size can be reduced by a factor of four. This is a reflection of the fact that in order to double the accuracy of results at a given confidence level, the sample size must be quadrupled. Since surveying precision increases much more slowly than sample size, and increasingly slowly as the size gets large, the cost of a larger survey often is not justified by a rather measly improvement in the accuracy of the results. For that reason, most marketing research relies on sample sizes of between 100 and 400 units.

Nonstatistical Considerations in Choosing Sample Size

In *Marketing Research and Analysis*, Donald R. Lehmann notes several reasons why the proper sample size may have little to do with mathematical validity.

Many users of marketing research are only comfortable if data is derived from a sample of at least 100, for instance. That may be a lot more than the situation requires statistically, but there's often nothing to be gained by trying to make that point. A researcher could very well lose credibility with a client who comes away with the notion that the researcher simply has lax standards.

Similarly, users might have a policy, stated or derived from past practice, that a sample of 1,000 is the absolute maximum needed for any research. That might well yield rather uncertain results for subgroups within the sample that number far less than the magic 1,000, but bucking established policy can be fruitless. If a researcher can somehow manage, it might be best to go along.

Finally, in cases where survey money has already been budgeted, Lehmann provides a "very scientific formula" for determining sample size:

"Take the budget (SP), subtract fixed costs of the study (EN) plus any dinners, trips or expenses we can charge to it (D) and then divide by the variable cost of sample point or interview (IT). This leads to the very scientific formula:

$$n = SP\text{-}EN\text{-}D\,/\,IT$$

This formula is, in reality, every bit as important in determining sample size as those relating to the statistical precision of the results."

CHAPTER 5

SOURCES OF DATA

Market data, suitably organized and analyzed, is the basis or at least the justification for most marketing decisions. There are thousands of sources of market data.

INTERNAL DATA

The best, most accurate, and least expensive source of market data is often right under a marketer's nose. Internal company sales records, accounting records, prior marketing research studies, company personnel and customer surveys can provide a wealth of valuable information that can be used to refine existing products, develop new ones and fine-tune marketing practices.

For example, sales receipts can tell a company a buyer's location, types of products purchased together, how the buyer intends to use the products, prices paid, buyer's business, dates and frequency of purchases, volume of purchases, how and who sold the product and how the product was paid for. Meanwhile, accounting reports can reveal how much a product cost to make, how much was spent on various marketing activities and what kind of investment return has been achieved.

ADVANTAGES OF USING INTERNAL DATA

Advantages of using *internal data* versus outside sources are that the cost is low, the data is readily accessible, it is highly reliable and it is apt to have more relevancy to the issue at hand. Internal data should be the starting point for most marketing research. At a minimum it can effectively narrow the focus of research, either by highlighting areas with potential or by eliminating options that show insufficient promise, before more expensive *external data* is collected.

Say the Nekoosa Foundry Co. has set a goal of expanding its profits by 25 percent in the next year. It can accomplish that by maintaining its existing profit margins and increasing sales by 25 percent, by maintaining sales volume near current levels and increasing profit margins or by some combination of the two strategies. Internal records may well indicate which approach has more promise. Perhaps there is an unserved geographic market adjacent to one where the company is already active. If the existing territory is productive and growing, it may indicate that the adjacent market could be profitably targeted. Or sales records may show that certain types of customers have been converted to a better grade product that generates higher profits. Further analysis may reveal other similarly situated customers who can be likewise upgraded with a concerted marketing effort.

EXTERNAL DATA

In many cases, internal data can point the way, but it will be incomplete or insufficient. Outside data will have to be obtained, at least to fill the holes. Once that decision is made, there are many options to choose from. External data can be gathered by a company's own personnel or an outside marketing research firm can be enlisted. The former option can be cheaper, but if internal personnel have to be pulled from other important duties, the savings may not be worth it. Company personnel also have an advantage in knowing the company and its capabilities better, but that has to be offset against any lack of training and experience in marketing research. It may also be necessary to reveal confidential information—about a proposed new product launch, for instance—that could be leaked by employees to competitors prematurely. Confidentiality

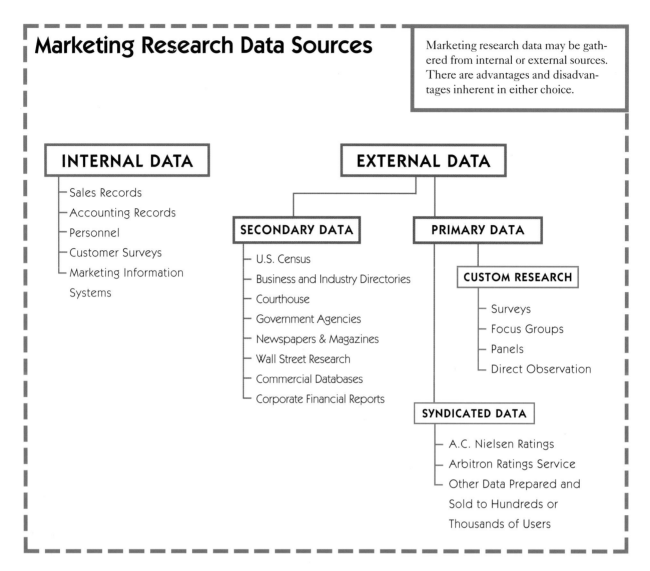

Marketing Research Data Sources

Marketing research data may be gathered from internal or external sources. There are advantages and disadvantages inherent in either choice.

INTERNAL DATA
- Sales Records
- Accounting Records
- Personnel
- Customer Surveys
- Marketing Information Systems

EXTERNAL DATA

SECONDARY DATA
- U.S. Census
- Business and Industry Directories
- Courthouse
- Government Agencies
- Newspapers & Magazines
- Wall Street Research
- Commercial Databases
- Corporate Financial Reports

PRIMARY DATA

CUSTOM RESEARCH
- Surveys
- Focus Groups
- Panels
- Direct Observation

SYNDICATED DATA
- A.C. Nielsen Ratings
- Arbitron Ratings Service
- Other Data Prepared and Sold to Hundreds or Thousands of Users

is easier to maintain using outside researchers who may not even know who they're working for.

Hiring outside researchers may require a bigger cash outlay, but the quality of the data obtained and the ability to avoid disruption of internal functions might warrant it.

SECONDARY DATA

External data falls under two basic categories: *secondary data* and *primary data*. Secondary data is market data that's collected without any specific purpose or user in mind: government census data, industry data compiled by trade associations, business and industry directories indexed by industry type or SIC (standardized industrial classification) codes, courthouse data or data from other local government agencies, newspaper and magazine reports, financial reports prepared by corporations,

Wall Street financial research and industry reports, commercial databases, even telephone books. The sources are almost endless, and costs vary widely. Public libraries are full of secondary data sources, many of which cost nothing other than the time devoted to seeking them out.

PROS AND CONS OF USING SECONDARY DATA

Advantages of using secondary data are its low cost compared to custom research, its ready accessibility, and the broad depth and scope of the data made feasible by economies of scale. A small company could never afford to survey hundreds of thousands of potential customers on its own, but as a user of a commercial database service, it can get much the same benefit for a fraction of the cost. Disadvantages of using secondary data include the possibility of getting more data than

you can process; an inability to focus on buyers, geographic areas or questions specific to your problem; misleading analyses or misinterpretation of data by an outsider; unknown errors in collecting data; and old or stale data that no longer reflects the market accurately.

Marketers should be on guard against bias whenever using data from trade organizations and government agencies, which often issue reports that are intended to make themselves appear attractive to investors or prospective customers. State departments of commerce and local chambers of commerce can supply all kinds of data for marketing programs, but their primary mission is to generate economic development in their areas. That can cloud their reporting. For that reason, it may be best to get secondary data in as basic a form as possible rather than rely on the sponsoring organization's possibly self-serving interpretation and analysis.

PRIMARY DATA

Primary data is research data collected via a survey for a specific marketing purpose. That includes *syndicated data* that's sold to hundreds or thousands of different users, such as TV and radio audience ratings compiled by A.C. Nielsen and Arbitron Ratings Service, as well as *custom research data* that's compiled by marketing research firms based on individual client needs and according to their specifications. Primary survey data is collected using *questionnaires* or interviews, as with telephone and mail surveys and *personal interviews*, or through personal or electronic *observation*, such as the use of scanners in supermarket checkout lanes. Observation has the advantage of being more accurate, more objective and generally less expensive. Questionnaires, however, can reveal people's motivations and additional demographic or psychographic data that isn't apparent through mere observation.

Surveys can be simple one-time studies that measure attitudes, opinions or experiences at a moment in time, or panel studies that track the same individuals, households or businesses over time. Controlled *experimental studies* set up separate samples with different conditions—each group may be asked to use a different version of a proposed new product, for example—then compare the results with one another. Experimental studies allow researchers to more thoroughly test different variables, but the cost of collecting data is correspondingly higher.

Choosing the appropriate data sources depends on the problem at hand and how much money and time researchers can afford to spend. In that sense, marketing research is more art than science. It can be costly, but conducted properly it's much less expensive and more informative than trial and error. Avoiding the development and launching of a product that nobody wants to use or pay for—Ford's Edsel remains the classic example—can justify a lot of marketing research.

6

COLLECTING DATA: SURVEYING AND OBSERVING

Surveying is the principal way researchers collect custom research data for marketing research studies. During a survey, marketing researchers question people about their buying habits, opinions, attitudes, intentions, likes, dislikes or whatever. There are several kinds of surveys—face-to-face, telephone, mail and self-administered being the major ones—each of which has certain advantages and disadvantages in particular situations and each of which entails certain costs.

Some marketing researchers also refer to observation as a method of surveying. That makes sense since the data generated by either is treated in the same way. Any distinction is mostly semantic. For the purposes of this chapter, however, we'll examine observation methods separately.

The trick for a researcher is to pick the survey method that will deliver the data he or she needs with the most precision and reliability and the least cost. Practically speaking, it is often a case of balancing cost, in terms of money and time spent, against data quality. That's where the art of marketing research becomes as important as the science.

FACE-TO-FACE INTERVIEWS

Conducting face-to-face interviews is generally the most costly type of surveying, since interviewers have to be trained and substantial time must be spent by the interviewer for travel and the actual interviewing. It can also be the most informative method of surveying, however, since interviewers can pick up nuances and tailor follow-up questions depending on a subject's response. If a subject doesn't understand a question, the inter-

viewer can rephrase it, for example.

Let's say you are asking subjects to the rate the visual impression made by proposed packaging for a new fat-free, low-calorie breakfast bar made from orange peels and peanut skins. The interviewers show subjects a series of boxes, stopping after each one to elicit a rating of between 1 and 10, with 1 being along the lines of "makes me sick to my stomach" and 10 being "irresistible."

If an interviewer shows the first box and says, "How would you rate this box from 1 to 10?" and the subject responds "That's very attractive. I'd really be tempted to try a product like that. I'll give it a 1," something is obviously wrong. In a face-to-face interview, the interviewer can go over the instructions again to make sure the subject understands the rating system correctly. If the instructions are frequently misunderstood, it may be a sign that they need to be revised to make them clearer.

If the same data was being collected with a mail survey, however, researchers would have no way of knowing that the instructions were being misunderstood. Instead, that highly favorable rating would be fed into the database and mistakenly interpreted as highly unfavorable.

DISADVANTAGES OF FACE-TO-FACE INTERVIEWS

A major drawback of face-to-face interviews, also commonly referred to as personal interviews, is that there is an opportunity for the interviewer to influence the responses. By consciously or unconsciously changing their tone of voice or facial expression, interviewers can

subtly affect the responses that subjects give. People tend to give responses that please the person asking the questions, so any bias on the part of interviewers that's picked up by the subjects can skew the results. To minimize *interviewer bias*, questions and techniques have to be designed with great care and interviewers need to be carefully trained. All of that adds to the cost.

A common way to keep the cost of personal interviewing down is to conduct what is called an *intercept study* where subjects are picked out on the street, at a shopping mall or some other public gathering place. This avoids the cost of having the interviewer travel from place to place seeking out interview subjects. Researchers have to be aware, however, that they have less control over the choice of subject interviewed in intercept studies and it also opens the door for other biases to be introduced by the interviewers. If an interviewer doesn't like redheads, they could be excluded from the sample without anyone ever knowing it. And if the research concerns hair colorings, that could easily skew the results.

Telephone Surveys

Telephone surveys are generally cheaper than face-to-face interviewing since interviewers don't have to spend time traveling to the subjects. Instead they can knock off dozens of interviews an hour over the phone. With automatic dialers and recorded messages, personnel costs can be reduced even more.

Those costs savings, however, come at a price in terms of the quality of data obtained. Telephone interviewers can elicit information and opinions, but they can't show the subjects anything or have them taste, smell or feel a sample product.

Mail Surveys

Mail surveys are potentially the cheapest, mainly because they don't require costly live interviewers. A good questionnaire only needs to be designed once, then mass produced and mailed to prospective subjects. The incremental cost of adding more subjects is very low, but on the other hand, the response rate is also low. Getting enough people to respond to mail sur-

INTERACTIVE RESEARCH

Interactive research is a rapidly growing method of data collection for marketing research. It involves the use of various computer devices, including kiosks and desktop systems, with participants responding to on-screen stimuli or questions.

Advantages are several. One, it may produce more truthful replies than face-to-face interviews. This is particularly useful when the survey topic is intensely personal, socially taboo or possibly illegal—whenever the interview subject might be inhibited from speaking freely. Two, interactive research involving large samples can also be cheaper since it eliminates the expense of paying interviewers, then coding and entering data. With a computer, the data is collected, automatically coded and seamlessly entered into a database.

A third advantage is that the sequencing of questions is controlled, unlike with mailed questionnaires, and people can't go back and change previous answers. It can also provide almost instantaneous data correlations for analysis.

Disadvantages of interactive research are that it necessitates keeping questions fairly simple, especially compared to face-to-face or telephone interviews. Also, there may be a bias in that people who are unfamiliar or uncomfortable with computers or keyboards will shy away from participating.

veys can be difficult, particularly if they are not pre-screened for a potential interest in the subject, product or service being researched. High nonresponse rates can skew results. Besides cost, other advantages to mail surveys are the ability to enclose samples or representations of new products, something that cannot be done in a telephone survey. Also, since there are no live interviewers involved, the possibility of interviewer bias is eliminated.

SELF-ADMINISTERED SURVEYS

Another type of data gathering technique used by marketing researchers in select situations is called a *self-administered survey*. That's a fancy name for the customer response cards you often find in hotel rooms or restaurants. This is a very inexpensive way to gather information—just the printing costs and maybe the cost of mailing the completed cards in—but it's subject to a number of potential biases that make it highly suspect as a means of quantifying attitudes or opinions with much accuracy.

The biggest problem is that customers' willingness to take the time to fill out response cards is very much dependent on their having strong feelings one way or another about the product or service. The people who bother tend to be those who are either very pleased or very dissatisfied. As such, it's a good way for a central office to uncover deficient performance by a distant franchisee or manager, but not so good at figuring out what percentage of customers are repeat customers or just how satisfied they are.

OBSERVATION TECHNIQUES

Personal observation can range from the very objective task of counting cars, shoppers or purchases to very subjective things like how tools are used in a manufacturing plant. A research project by a major car maker once categorized car shoppers in showrooms according to how they were dressed, their assertiveness and other characteristics that were ascertained by visual observation.

Observation can also be conducted using mechanical or electronic devices. Car counters in a roadway are commonly used by traffic planners to estimate the volume of cars that normally travel on a road and peak driving times. Scanners that read *universal product code* (UPC) labels, or bar codes, not only ring up prices but are used to track inventory, reorder merchandise and gauge the effectiveness of various promotions.

Scanners are employed by marketing researchers in people-meter studies as a means of compiling single-source data. For example, TV viewing habits of family members in selected households may be monitored electronically and correlated with purchases of consumer products, which they scan into the same devices.

7

TESTING

While marketing research is often used to gauge attitudes toward hypothetical products or product refinements, it's also widely used to test how real products are doing in the marketplace. Producers and distributors employ various methods to measure how much market share they are garnering, where their products are selling, how much shelf space their products occupy, sales in dollars and unit volume, what prices they're selling for, and how their products are displayed.

The most important tool for measuring product movements is the UPC label or bar code that's now affixed to almost all consumer packaged goods and increasingly to other products as well. It allows retailers to automatically ring up prices, control inventory and track sales. It also allows producers to track their product movements through data services that survey UPC data at thousands of outlets across the country. That data can then be almost instantly cross-tabulated and correlated to tell marketers how products are selling.

SINGLE-SOURCE DATA

A big advance in marketing data is the development of what is called single-source data. Traditionally, if sales of a product increased following a promotion, marketers might assume that the increase was caused by people who saw a TV commercial and responded by buying the product. But they wouldn't know for sure one caused the other if they only measured product movement.

Single-source data services improve on the quality of information by tracking a large panel of consumers, monitoring not only product purchases but also their exposure to commercials and ads, use of coupons, behavioral characteristics and attitudes toward prod-

ucts. Several national research firms conduct these ongoing, electronic surveys of product movements and consumer motivations, then sell that data to producers and marketers.

TEST MARKETING

In an era of national brands supported by national ad campaigns and national distribution networks, launching a new product, a product improvement or even a promotional campaign for an existing product costs millions of dollars. Marketers cannot afford to invest that kind of money without first ascertaining that the launch has a reasonably good chance of success. To gauge the likelihood of success, they engage in various *test marketing* techniques to uncover problems before they throw millions of dollars down the drain.

The concept of test marketing is to stage a limited trial run, generally of the entire marketing mix, in a location that's likely to yield results comparable to those in the overall target market. Good test markets for national consumer products are generally midsized cities where media outlets do not overlap with larger markets, where national retail chains operate in a fairly typical manner and number, and where the demographic composition of the population is similar to the nation as a whole.

In conjunction with test marketing, consumer tracking studies are generally conducted to see how consumer attitudes and awareness change as the test progresses.

TRADITIONAL TEST MARKETING VS. NEWER TESTING METHODS

The biggest problem with this kind of test marketing is the test has to be long enough for the bulk of the population to be exposed to the product and have an

opportunity to buy it. If most people buy automobile tires every three years, a three-month test will only reflect the reactions of a small percentage of the population.

Long tests, however, cost a lot of money and raise the risk of tipping off competitors to new marketing initiatives. Being first on the market can be a huge advantage with a new type of product, and often that advantage is necessary to justify development costs. Another danger is that competitors may purposely alter their own marketing—by cutting prices and running big promotions, for example—in order to skew the test results.

Today, most consumer goods companies use shortcuts rather than traditional test marketing. Most employ either *controlled tests* in which products are placed in selected stores directly by the company, or *simulated testing* designed and conducted by research firms to predict consumer behavior using specially recruited panelist/buyers in simulated buying situations. These techniques can greatly reduce the cost and duration of market tests and reduce the chance of unnecessarily tipping off competitors.

FOCUS GROUPS

Focus groups are often used in preliminary research to test ideas or concepts before proceeding with costlier stages of development. A focus group of five to ten carefully selected people led by a skilled, professional moderator can uncover many problems early and avoid mistakes that would otherwise end up costing much, much more. Although some marketers mistakenly do so anyway, focus groups should never be used as a source of quantitative research data. The sample size of a focus group is much too small to generate any statistically significant data, and the interaction of the group members and the input of the moderator would hopelessly bias any quantitative data derived from their proceedings.

A common usage of focus groups is to develop questionnaires for a quantitative study. Besides concept testing for new product research, focus groups are also used for screening advertisements.

PANELS

Marketing researchers often assemble groups, or *panels*, to monitor members' responses over time. As in any survey, data can be gathered by mail, in person or by telephone. Some panels are short-lived, while others may be continued for years.

A big advantage of using a panel is that, once a good sample is obtained that meets all the requirements of a research project, it's cheaper to reuse the same sample rather than go out and find a new one each time. The development of a close relationship between panel members and researchers tends to cause panelists to have high response rates, to show more willingness to discuss delicate subjects and to be easier to contact for follow-up questioning.

A potential disadvantage of panel research is that the panelists' self-consciousness about being a part of the panel may influence their behavior or the opinions they express.

TRACKING THE COMPETITION

A key element in any marketing decision is knowing the competition. If marketing research tells the Deep Freeze Delights Co. that there is a huge consumer demand for frozen beer on a stick—beersicles—and it decides to develop a product to take advantage of that opportunity, it might be helpful to know that a German brewing company already has such a product on the market in Europe and is planning to launch it in the United States next spring. Deep Freeze could certainly benefit from knowing how much they'll charge for the product, how big a promotional campaign they plan, what experience the brewer has with American sales and so on.

Fortunately, there is a wealth of information available on many competitors and prospective competitors. It doesn't require sophisticated industrial espionage or expensive primary research. Much of it, in fact, is in the public domain and available upon request or through a simple search at the public library.

Sources of information include the companies themselves; their former employees; analyses of competitors' products; government regulatory agencies; private publications such as newspapers, trade journals and popular magazines; trade associations and directories; local or state chambers of commerce; investment research firms; and personal observation. Best of all, the cost of gathering this information can be very cheap.

GO TO THE SOURCE

The place to get the most plentiful information about a company, its products and its marketing efforts is the company itself. When you think about it, they know more about themselves than anybody else, so it makes sense. Most business enterprises churn out all kinds of information in their attempts to promote themselves or their products and services. Sales brochures, price lists, advertisements, trade shows, help-wanted ads and press releases all may contain information valuable to any competitor. While the information may not be as objective as information from an impartial source, an outside observer who is knowledgeable about the industry can usually separate puffery from facts, and hard facts from suspect facts.

Former employees can be a source of inside information that might not be available elsewhere. These often cooperative sources may be as close as your company's or your client's own personnel files. If they are disgruntled about their former employer or eager to make a good impression with a possible future employer, their information could be invaluable.

REGULATORY AGENCIES

Government regulatory agencies—U.S. and foreign—collect all kinds of financial data and analyses of various companies' operations. Companies that have stock (equity) or bonds (debt) that are publicly traded in the securities markets are required to file detailed quarterly reports (Form 10Q) and *annual reports* (Form 10K) with the U.S. Securities and Exchange Commission. They are also required to send similar reports (usually glossier versions) to all of their shareholders and will often mail them out to anyone who requests them.

These reports contain detailed financial figures on overall sales, expenses, costs of goods sold, profits and capital expenditures. They also break down information for various geographic and product segments, although companies usually manage to define those segments in such a way as to reveal as little as possible to potential competitors. If a company about which you

are seeking information is owned by a public company, the information about that subsidiary might well be broken out separately in this segment information, or it may be combined with other company operations. Even then, however, useful insights can still be gained from it.

Annual and quarterly reports also include discussion and analyses of business developments by top management. Frequently they will address specific product lines and reveal future plans for them. While they are not likely to come right out and reveal trade secrets, just knowing what they do reveal can tell a competitor a lot about what they choose not to say.

Beyond Annual Reports

Other filings that companies are required to make disclose significant changes in operations between quarterly reports, such as the acquisition or disposition of major assets.

If any of these filings are not available directly from the company, many public libraries have access to the documents through electronic database services that are hooked into the Securities Exchange Commission. Searching these are simple; type in the company's name and the program will list all of the recent filings it has made. Generally, the information is free.

Privately held companies sometimes have to disclose information to government agencies as well. The Federal Communications Commission requires certain public disclosures anytime a broadcasting license is transferred to a new owner. State insurance commissions have information on insurance issuers that operate in their states. And the U.S. Patent Office and the Food and Drug Administration require information about new products.

Almost any company that operates in a regulated industry has information on file with the overseeing agency that might be of value to a competitor. In most cases, the information is freely available to the public.

Local Courthouses

Local government agencies are yet another potential source of competitive marketing intelligence. Real estate records may reveal just what sites a retail chain owns, or more important, what sites it has purchased, how much it paid (which can give a competitor an idea of how much they expect to generate in sales and/or profits) and how it financed the purchase. Property records can also reveal if someone has acquired an option to purchase a site.

Court documents are often brimming with inside information about a competitor's operations and business practices. If someone is upset enough to file a lawsuit against a company, chances are they are likely to use every bit of information at their disposal, if for no other reason than to pressure the company into a settlement. Even if the company itself has brought the lawsuit, the defendant's documents may disclose sensitive matters that they already had knowledge of or which they gleaned from internal company records during the pretrial discovery process.

Debriefings

Other knowledgeable, yet often underappreciated, sources of information on competitors are a company's own personnel. Engineers, scientists, purchasing agents and other skilled personnel should regularly be debriefed when they attend professional meetings or seminars where they might be in a position to pick up knowledge of competitors. Often they gain valuable information but don't realize it if it concerns an aspect of the business with which they are not directly involved.

Through an organized intelligence-gathering process, employees can be prepared in advance to be on the alert for key information and then thoroughly debriefed upon their return.

TARGET MARKETING AND SEGMENTATION

Marketing effectively requires matching the right product and marketing mix with the optimum customer base, or *market segment*. No product and marketing mix is universally right for every market. Even Coca-Cola comes in a variety of packages and flavors, is delivered differently through channels such as supermarkets and fast-food restaurants, is priced according to specific markets and is promoted in a number of different ways depending what the target market is.

Market segments are typically viewed as multidimensional, with large, general segments subdivided into any number of more specialized subsets to form a matrix of intersecting and overlapping markets that share some characteristics and differ in others.

APPROPRIATE MARKET SEGMENTATION

Marketing success depends on identifying segment characteristics that can make a meaningful difference in buying behavior, that exist in sufficient concentrations to warrant distinctive marketing approaches and can be measured and identified within the population.

Marketing a service to a few hundred people who live within a half-mile radius of a small food store can be a good means of segmentation. Their common proximity may prompt them to shop there, there are enough of them to support a profitable operation and they are easy to identify and communicate with through sidewalk signs or handbills.

On the other hand, marketing a specially designed fork to the millions of people who are left-handed and eat pancakes for breakfast would probably fail because there's no good way to identify or reach those people in a cost-effective manner or to motivate them to buy your product—even if it's something they'd use regularly if they had one.

HOW MUCH SEGMENTATION? IT'S A BALANCING ACT

Effective targeting of market segments depends on finding the right balance between two extremes: on one end, having just one product and marketing mix for every person in the population; on the other, creating a distinct product and marketing mix for every buyer. The former strategy, while very cost-efficient, will in most cases fail to reach or convert the optimum number of potential buyers. The latter approach will win more buyers, but it costs too much, except in rare instances. Henry Ford could get away with producing one kind of car in one color for everyone. That strategy would be suicidal for today's car makers, as would an attempt to design and build a completely customized car for every buyer.

Successful marketing generally requires a balance falling somewhere between the two extremes, although with increasingly flexible manufacturing and distribution systems available through digital technology, the trend is decidedly in the direction of greater differentiation aimed at smaller and smaller market segments, or what are known as *market niches*.

Some targeted segments may require a very different marketing mix, others merely a slight variation on a common approach. In any case, the right marketing mix for a particular target market depends on the characteristics of that segment. Marketers need to understand those characteristics if they hope to succeed in designing effective marketing plans to reach them.

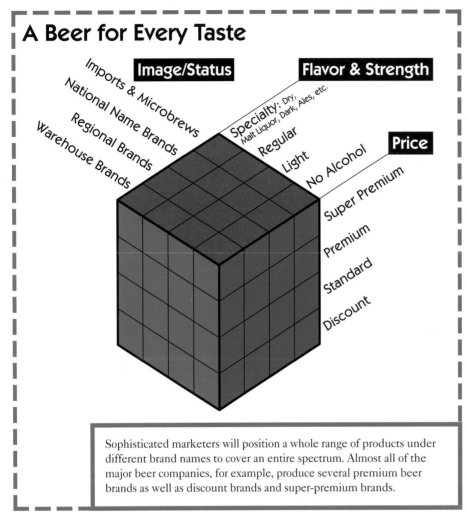

A Beer for Every Taste

Image/Status

Imports & Microbrews
National Name Brands
Regional Brands
Warehouse Brands

Flavor & Strength

Specialty: Dry, Malt Liquor, Dark, Ales, etc.
Regular
Light
No Alcohol

Price

Super Premium
Premium
Standard
Discount

Sophisticated marketers will position a whole range of products under different brand names to cover an entire spectrum. Almost all of the major beer companies, for example, produce several premium beer brands as well as discount brands and super-premium brands.

DEMOGRAPHICS, PSYCHOGRAPHICS AND PRODUCT POSITIONING

Market segments can be defined by any number of factors. Consumer product markets are frequently defined by geography, by *demographics* (age, sex, marital status, number of children, income levels, etc.), by consumer status, by consumer behavior, by distribution channels, by concentration, even by law, as with prescription and nonprescription versions of medications. Modern marketers also segment consumer markets by *psychographics*—a combination of psychological tendencies, demographics and lifestyle preferences. Business market segments might be defined by geography, industry, growth characteristics, numbers of employees, plant size or sales volume.

Product *positioning* is a concept that's closely linked with market segmentation. Once viable market segments have been defined and identified, and a *target market* selected, marketers must decide where and how

they want to position their product within it.

Market segments typically consist of various price levels, for example, which generally correspond roughly with quality levels, or at least perceived quality levels. Higher quality products can command a better price but generally require more promotion, while lower-priced products can get by with less than perfect quality and little or no promotion as long as consumers think they're still getting a good deal.

BRANDS AND MARKET ENTRY BARRIERS

A marketer's ultimate goal is to create a product that loyal consumers perceive as unique and preferable to any other substitute—to make it a market segment unto itself, at least in the perception of its consumers.

Marketers promote brand identification to create a psychological bond with consumers. The payback for a strong brand is in monopoly-like benefits: being able to command higher prices without significantly diminishing demand, building barriers to competition that keep other products from entering the market, and market stability over time.

Market entry barriers include various characteristics of a market that give an inherent advantage to those with an established position and which create difficulties for new competitors. Examples of entry barriers include an incumbent's favorable reputation, strong brand names, government licensing requirements, an exclusive distribution network, a patent on key technologies and a controlled source of scarce raw materials or components.

MARKETING RESEARCH REPORTS

Once research on a marketing problem has been completed, the findings need to be communicated to various people at different levels of the organizations involved. Graphic designers may encounter marketing research reports when they are introduced to a project, or they may need to compile or assist in compiling reports themselves to inform clients of research they've conducted or participated in.

Generally, different versions of reports are produced that reflect the varying needs of the people who use them. Some people need only a brief summary of a research project and its findings; others need more detail; and somewhere, all of the records and materials that went into a study will probably be organized for future reference. Graphic designers can be thankful that they probably won't have to wade through anything like that.

Whatever the level of detail, most reports will contain some treatment of the following basic elements.

REPORT SUMMARY

The report summary is a quick, executive summary of the problem, what has been learned and the recommendations that flow from it. This can be as short as a paragraph or two. It's designed for people who don't need to know much about the research but may be responsible for or affected by its outcomes. It's brief, concise and nontechnical.

STATEMENT OF THE PROBLEM

This section of the report defines the problem that gave rise to the research. This should be the real,

underlying problem as it applies to the organization, not just the stated objective of the research.

For example, the stated research objective might be to determine the optimum price at which the company should introduce a new service. The underlying problem, however, might be that intense competition from providers of related services has forced the company to cut its gross profit margins in order to maintain a certain volume of orders. It has decided to upgrade in order to distinguish itself as a specialist offering higher quality and more-advanced technological capabilities. The upgrade will entail a significant investment. In order to structure financing most favorably, the company needs to project how much it can make at various price levels and how quickly it can expect to recoup its investment.

Defining the real problem rather than merely restating the research objective puts the research in full context for people who are not directly involved with it. A report may contain more or fewer specifics about the problem, depending on the level of detail intended.

DESCRIPTION OF RESEARCH METHODOLOGY

This is a description and explanation of how data was collected, organized, measured and analyzed. In our example, it might involve questionnaires sent to customers and prospective customers and/or a survey of similar services offered in other markets.

This section should include any ways in which the data collection effort deviated from the plan and any consequences of that. Complex statistical details of the methodology and explanations or justifications for choosing those methods are usually reserved for in-depth reports.

FINDINGS OF THE RESEARCH

The findings are conclusions that researchers have drawn from their work in the context of the stated problem. In our example, the conclusions may be that introducing a service at a certain lower price level will result in a quicker penetration of the market and hence a faster payback on the investment. They may also have found that introducing the service at a somewhat higher price level, while lengthening the time needed to recoup the investment, should result in higher profits long-term, but that beyond a certain price range, profits will suffer because the price will discourage customers from using the service in favor of competitors' lower-quality but less-expensive services.

RECOMMENDATIONS

The final section of the report will state any major recommendations based on the statement of the problem and conclusions drawn from the research. In this case, since the stated problem is to introduce the service at the price that will most quickly recoup the company's investment, the recommendation would likely be to introduce it at the lower price.

This is not necessarily the option management will choose, as the research process itself may well have uncovered other considerations that were not initially thought of, such as higher long-term profits.

IMPLICATIONS OF THE FINDINGS

This section will cover the implications of the findings, including any recommendations for specific departments or personnel. Assuming the recommendations are adopted, these are the principal and/or immediate things that need to be done to follow through and implement them.

MARKETING TOOLS

The number of different marketing tools at marketers' disposal is limited only by their imaginations. This book, in the profiles that follow, examines a handful of the most common marketing tools, but they are by no means exclusive. Think of them as rough categories, from which creative marketers fan out, evolve, extrapolate, mutate, multiply and divide. There are always new mediums emerging that will bring forth fresh marketing concepts that no one has ever thought of before because the means of delivering them were not yet invented; always new ways to use old mediums, new concepts that defy convention, new attempts to attract attention by breaking away from the pack.

A few years ago, Jacor Communications, a rather flamboyant operator of one of the country's largest radio station groups, distributed an annual report to its shareholders on compact disc. The next year, a poster-size annual report was mailed out in plastic tubes. (Folding instructions were included so it could be made to fit in standard file drawers.) Those aren't the sort of tactics you'd expect from IBM or General Motors, but then, Jacor probably wasn't trying to attract that sort of investor. You can bet, however, that lots of media buyers appreciated the company's knack for getting noticed. That's targeting your market.

ADVERTISING

Advertising is a form of audio and/or visual stimulus or promotion for which an identified marketer pays the owner of a communications outlet to convey its message. It comes in a variety of forms and is generally nonpersonal in that it's targeted to a mass audience. TV and radio commercials, newspaper and magazine display ads, classified ads, billboards and public broadcast-

ing "underwriting" announcements are among the most prevalent forms of advertising.

Less obvious forms, or variations, that have gained popularity in recent years include event or location sponsorships such as the Winston Cup stock car racing series or Coors Field ballpark in Denver; contracts that call for athletes and other public figures to wear certain clothing or commercial insignias, and agreements to use identifiable products such as certain soft drinks or car models in movies and TV shows.

DIRECT MAIL

Direct mail is an alternative to advertising that is delivered directly to a home or business address of a preselected target audience. Advantages are that, since it can be sent directly to specific persons or addresses, it can be highly targeted, with a greater degree of assurance that people a marketer wants to reach will in fact be reached. For that reason, it can be more efficient than mass advertising in that the message need not be inadvertently delivered to a lot of people the marketer has no interest in reaching.

Most advertising through mass media is largely nondiscriminatory, forcing cigarette marketers, for example, to spend a lot of money on ads that reach nonsmokers who would never think of buying their product. With development of a good mailing list, direct mail marketers can avoid that kind of wasted effort. The only hang-up, however, is that it may cost a lot of money to develop or buy an effective mailing list, and the cost of reaching that targeted audience through direct mail can be higher than through a less-discriminating mass media.

Direct mail marketers may also suffer from an unsavory "junk mail" image that can keep people from

paying attention to their promotions. Advertising to a large degree carries with it the reputation of the advertising vehicle in which it's contained, so people who subscribe to a respected financial journal may be a bit more inclined to buy a newsletter that's advertised there than one that's promoted via direct mail.

Packaging

Marshall McLuhan popularized the saying "the medium is the message" in the 1960s. In terms of promoting consumer goods, he might well have rephrased it as "the packaging is the product." Traditionally, marketers have regarded packaging as part of the product mix rather than the promotion mix, but it's really part of both. Packaging—the physical means of wrapping and sealing individual products for delivery or sale—has long been an effective way to promote consumer products. Just look at the Coke bottle. The best packaging is both functional and promotional, serving to make the product easier to use—a squeeze bottle for ketchup—as well as aesthetically more pleasing. In some unusual cases, the package itself can be the reason a product is purchased, as with commemorative whiskey bottles shaped like Elvis Presley or race cars.

Environmental and Retail Signs and Displays

Signs and displays are used extensively in retail environments to direct customer traffic, to provide information about products and prices and to promote sales. Retailers increasingly provide segregated areas devoted exclusively to certain brands or manufacturers that are identified by highly visible signs. Often these marketers pay fees to the store for the space, fees they then recoup through profits from goods sold. These kinds of arrangements have been common in department stores and have been spreading to mass merchandisers and supermarkets.

Marketers also set up stand-alone displays in aisles or at the ends of aisles to distinguish products from those of competitors by setting them apart and by permitting a promotional element not possible on common shelf space. In-store displays are very effective in moving premium-priced consumer packaged goods.

Corporate Identity Campaigns

Corporate identity campaigns are a form of multimedia promotion designed to raise awareness of a family of products or services indirectly by boosting the image of its parent company. In many cases these campaigns are directed at a broad target audience that by itself may not represent a significant market for the company, but whose acceptance of it can indirectly lead to higher sales and profits.

Goodyear doesn't sell blimps, and Sears isn't known for its commercial real estate business, but the Goodyear Blimp and Chicago's Sears Tower have no doubt racked up many sales for each over the years.

Brand Identity

Similar in concept to corporate identity programs, brand identity efforts focus on building a brand name or brand image without necessarily touching on the branded product itself.

As David Arnold writes in *The Handbook of Brand Management*, "the real key to market leadership is superior *perceived* quality. . . . Because quality is driven by perception, branding is a key issue in attaining and keeping market leadership. The 'market power' that simply comes from being a leader gives a brand all sorts of other advantages, from bargaining power with the distribution trade to a general aura of quality."

Annual Reports

Companies whose stock is issued to the public and traded on the open market are required by the government to issue and mail out annual reports to all shareholders of record. These annual reports are required to disclose certain data about companies' operations and finances, as well as discussion by management of how the company has performed. Almost every company incorporates much of this information into a colorful, glossy, magazine-size brochure that is used as a marketing tool to promote its stock to investors and the financial markets.

These often-expensive, graphically intense brochures generally try to paint a rosy picture of a company's performance and prospects, even if the financial details required by law to be included indicate otherwise.

MARKETING ON THE INTERNET

In a sense, the Internet is just another medium for marketers to use to deliver products or services, or to deliver information about products and services to potential customers. It's no different in that sense than TV, radio, the telephone, various print publications or whatever.

On the other hand, the Internet is fundamentally different than any other medium due to its capacity to produce limitless copies of whatever you put on it, at virtually no cost to the creator beyond the fixed cost of producing the original.

Compared to a book, newspaper or magazine publisher, for example, someone dispensing information via the Internet has the same production costs no matter how many copies are published, and distribution costs that are limited to the nominal amount paid to an Internet service provider for storing the material on a server.

Compared to a broadcaster, who can only air one program at a time over a single channel, the Internet offers an unlimited number of channels and it can rebroadcast a single program an almost infinite number of times at no additional cost. Because of that, the Internet has the potential to revolutionize marketing, which is so heavily reliant on communications media and distribution channels.

The Internet Is a Consumer-Driven Medium

The Internet is a rapidly evolving advertising/marketing medium that offers some intriguing possibilities. Unlike with traditional advertising mediums—broadcast, print, billboards—getting a message across via the Internet is mainly consumer-driven. That is, the person or persons who get the message in most cases have to take some specific, conscious action to get it. They are unlikely, or at least much less likely than with traditional media, to simply run across it by chance. If you advertise on TV, you can count on people seeing your ad who certainly had no intention of watching it when they sat down to watch their favorite show. Likewise, if you buy a magazine ad, many people are going to at least skim over your ad or be exposed to its message while paging through looking for something else. And, of course, when you put your message on a billboard, you grab the attention of everyone who happens to go by whether they want to see it or not.

Most marketing on the Internet, however, requires a bit more effort on the receiving end. If you put up a home page for your company, you've got to make it interesting enough and update it often enough that people will take the time to call it up and look at it. You might get a certain amount of traffic just by chance or because you get linked up via hypertext with other popular sites, but in order to generate repeat visits, people need a good reason to make the effort.

For most companies, annual reports (and also smaller quarterly reports) are major productions and usually their single most important investor-relations project for the year.

PUBLIC RELATIONS

Public relations and *publicity* are nonpaid communications tools—as distinguished from paid advertising—that companies use to promote their policies or products. Since they are not paid for and often do not directly identify the company itself as the source of the information, public relations efforts and publicity can often have more credibility than advertising or other more overt forms of promotion.

They can also be more cost-effective since they do not entail direct costs—a front page news story announcing a breakthrough product in a leading trade journal "costs" nothing, and is often regarded as "free" advertising—but staffing and maintaining a professional public relations effort is certainly not free.

SALES PROMOTIONS

Sales and trade promotions include brochures, pamphlets, volume discounts and giveaway items at trade shows that are targeted to distributors and retailers of a company's products, as well as discount coupons, free samples, specials and contests aimed at consumers.

They can be highly effective at selectively stimulating sales and moving products, but many companies have found that they can also be habit-forming. As car companies found out with automobile rebates, once people get used to them, they have a tendency to refuse to buy the product without them. Or worse, once the novelty wears off, buyers begin to view them simply as price adjustments on over-priced products, opening the door for discounters to enter the market with lower everyday prices.

Effective promotions generally have to offer something new or different. They work best as long as they're perceived as "special."

DIGITAL PROMOTIONS

Digital promotions are a relatively new form that emerged in the 1990s as the cost of digital technology declined to the point that it could be used to reach mass audiences and still be cost-effective. Digital promotions are fundamentally different because of the two-way, interactive capabilities of the technology and the ability of marketers to cram so much information into small spaces.

Digital promotions can be delivered via the Internet on home pages; via video kiosks in shopping malls, airports or other public gathering places; CD-ROMs; or, particularly as costs come down further, stand-alone digital devices dedicated to specialized functions.

Because of the newness and rapid changes still taking place in digital technology, initial production and maintenance costs tend to be high. As more and more media services providers get into the digital end of the business and as industry standards evolve, however, costs should moderate.

Case Studies and Gallery

12

CORPORATE IDENTITY

Companies spend millions of dollars to create and refine their identity, to promote it and to protect it. But a corporate identity program can only be successful if the company has clearly defined its market and has a distinct notion of what it must do to maintain a competitive edge in that market.

In the most basic sense, corporate identity represents business strategy as well as corporate culture. As Rose DeNeve writes in her book *The Designer's Guide to Creating Corporate I.D. Systems*, "Corporate identity is no longer merely 'a bug and a logo.' If visual identifiers were once seen as cosmetic or decorative elements belonging to the realm of public relations, they are now the children of business strategy, reflecting well-thought-out business plans." They also reflect the culture of the company, she writes. "Just as American culture helps to define our idea of what America is, so, too does a company's culture contribute to its identity."

STEP ONE: YOU HAVE TO KNOW THE CLIENT

For the graphic designer, then, developing a corporate identity system means knowing the client company as well as you know your own business. You must understand its historical development, its mission and goals and its philosophy on growth and progress. You should know its products and services, its customers and competitors and the forces (economic, political or social) that affect its industry. You must determine how employees, customers and competitors perceive the company and judge how those perceptions compare to reality. In her book, DeNeve suggests asking:

• How is the company structured? How is it managed?

• How has the company evolved or how has the business changed over the last five to ten years?

• What trends are affecting the industry and how is the company anticipating them?

• How does the company sell its products or services?

• What does the company do well and not so well?

• Who are the important publics, i.e., employees, customers, potential customers, investors, analysts, the community? How does the company communicate with them?

• How is the company perceived by its publics? Do perceptions match the image the company wants to convey?

• How does the company's existing graphic identity support management's vision? Is that identity distinct from the competition?

• Is the company's identity communicated consistently?

• Does the company have specific communication objectives? What are they and how has the current identity program been meeting them?

• What has motivated the company to redefine or redesign its corporate identity? What does it hope to achieve with a new identity program?

The research you do and information you collect will help you develop an identity that communicates the essence and philosophy of the company. It's not enough to be creative and unique; you must assume the roles of employee, manager, customer and competitor to successfully assess what image will communicate the company's strengths, mission and overall culture.

White Design Guides Barrington Identity Program

PROFILE: WHITE DESIGN, LONG BEACH, CA

FOUNDED: 1988, by John White

EMPLOYEES: Thirteen, including vice president of marketing, vice president of account services, creative director, four designers, project manager, production manager, production artist, vice president of administration, office manager and receptionist

SERVICES: Marketing collateral and corporate communications systems

MAJOR CLIENTS: Levi Strauss, American Isuzu Motors, Southern California Edison, FHP Healthcare

FORMAL MARKETING TRAINING/EDUCATION: "Having been in the business for seventeen years, you tend to have earned your own marketing MBA," says John White.

Litigation consulting firm Barrington was in its last phase of start-up when it approached Long Beach, California-based White Design to create a corporate identity and collateral system. Barrington was founded in 1990 and has offices in eight major metropolitan areas around the country. It has roughly one hundred employees with backgrounds in engineering, construction management, accounting and business who consult with attorneys and serve as expert witnesses. Barrington's director of administration, Hal Meggison, recalls his first meeting with designer John White of White Design. "He was dressed 'a certain way,' and then in the next meeting, he was dressed a little more conservatively, and by the third meeting, he looked like one of us."

White's change in dress is a subtle indication of how he approaches any design project: understand your market and assess what appeals to it. "You really need to investigate who the end user is," White says. And you don't need a marketing degree or MBA to do that.

Instead, White spent weeks analyzing

Barrington's existing materials, auditing competitors' brochures and traveling around the country to each of Barrington's offices where he interviewed more than thirty managers to determine the image the company wanted to convey and the materials that were needed to do it.

STUDYING EXISTING MATERIALS

As a young company, Barrington had never developed a cohesive marketing collateral system, relying instead on managers in individual offices to prepare the materials they needed to sell the services in which they specialized. More often than not, new business was secured by word of mouth or referrals.

"We recognized the need to establish ourselves in a highly competitive national marketplace," Meggison says. "When we approached White Design—which had designed the marketing brochure for a competitor—we clearly expected not only great design but marketing-related assistance as well."

Barrington has offices in San Francisco; Los Angeles; Phoenix; Chicago; New York; Washington, DC; Dallas and Atlanta. White collected samples from each office of the communications materials they were currently using for sales tools, such as letterhead and proposal forms. He also got a list of what each office considered its top ten competitors and sent away for their brochures and marketing information.

White photographed the communications tools from each of the eight offices and analyzed the inconsistencies among them.

"For the most part, we found that marketing materials from each office varied greatly in both the written and physical presentation," White says. "They had several logotypes, as well as different colors, paper stock, binding and tabbing systems. They lacked in uniformity and we felt that this was deterring both clients and staff people from forming any type of cohesive image of the company."

White also photographed six or so of what he considered the best competitors' marketing materials and analyzed them for their strengths and weaknesses. Marketing materials from competitors ranged from simple hand-bound booklets to elaborate full-color pack-ages. Most competitors had comprehensive general information brochures, though, that ran between twelve and sixteen pages.

FORMULATING A MARKETING STRATEGY

All of this was put together in a slide show format and this presentation was taken on the road to each of the offices to demonstrate the company's strengths and weaknesses and to show how competitors were excelling over Barrington in many areas of marketing.

At these intensive "input meetings," White questioned managers and key staff people on the services offered by the individual office, the image they wanted to project in their marketplace, the types of marketing materials they felt were needed, the advantages and disadvantages they had in comparison to competitors and their goals for the next five years.

Key personnel at the offices consisted of middle management to partner level. Each had expertise in his or her own practice groups and had particular interests in what the marketing literature should do and say.

IDENTIFYING PROBLEMS

White developed a synopsis based on information from the interviews that addressed a number of marketing issues.

"We found that each office appeared to act independently of one another, generally unaware of each other's activities," White says. There was no concerted effort to promote the company as a whole. Instead, managers had a tendency to "sell" themselves or their own offices, rather than the firm. And, any effort to market Barrington as a national firm was hampered by a lack of consistency and poor marketing materials, and particularly the lack of introductory or comprehensive collateral that can cross-sell the firm as a whole. "That can be a major competitive disadvantage during opportune times," White says.

White also observed that even though the collective expertise at Barrington is extensive, there are some locations where Barrington's managers are younger and considered not as experienced as those in more established firms. Barrington is positioned between the Big Six accounting firms and smaller partnerships.

"This perceived lack of experience can be a major obstacle to producing business and increasing clientele," White says.

Also, because the firm had not developed a consistent look in its communications, there was a real lack of name recognition. In terms of marketing materials, White found that Barrington's younger managers were very interested in redoing all existing literature and saw a real need for a full marketing system to assist them in their sales endeavors. The older executives did not feel there was a great need for this and were operating from their existing client base.

White came up with a set of recommendations for a new corporate identity and collateral that would position Barrington as a major player in the national marketplace.

Solving Problems

Based on feedback from managers, White understood that the company wanted to present itself as conservative, yet elegant. Barrington operates in an old-school, high-stakes environment where the work it performs is critical to the success of its clients' efforts. "We have to convey an understated yet high-polished image," Meggison says. "It's like wearing a $3,000 business suit—you recognize its high quality immediately."

White also thought the company name, "The Barrington Consulting Group," was too long. A shortened name—Barrington—and a descriptive tagline would be more suitable. He created a logo based on the letter "B" that incorporates the image of a classic architectural column. It connotes quality, experience and integrity, reinforcing the association between these characteristics and the Barrington name. A logotype and the tagline of "Business and

Barrington's existing marketing materials varied greatly in both the written and physical presentation. They had several logos and logotypes, as well as different colors, paper stock, binding and tabbing systems.

Engineering Solutions" were also developed. The logo and logotype are applied to all business forms and external correspondence, including fax sheets, memo sheets, letterhead, business cards, envelopes, mailing labels, invoices and proposals.

In his recommendations, White stressed the need for Barrington to develop a flexible marketing collateral system consisting of a general company brochure, practice area brochures of Barrington's high-profile cases, and other pieces, such as resumes, billing sheets and reference lists, which can be assembled in a presentation folder per client needs and requests.

The capabilities brochure features dramatic full-color illustrations that reinforce Barrington's expertise in providing solutions for its clients. The cover illustration is of a conservatively dressed male figure (repre-

senting Barrington) holding a key and showing another male figure (the client) which door he should pick and which path he should follow to find the solution to his problems. The theme is supported throughout the brochure. On one inside spread, for example, we see an arrow weaving through the jungle (the business world) to hit the bulls eye of a target.

White also produced six practice group brochures. The same style of illustration is used for each. Colors and type are consistent and the Barrington "B" appears boldly on every piece.

Each piece serves as a tool for client communications. "They help managers convey the desired national image for Barrington and are indicative of their expertise and commitment to high-quality client service, creativity and success," White says.

White created a logo based on the letter "B" that incorporates the image of a classic architectural column. It connotes quality, experience and integrity, reinforcing the association between these characteristics and the Barrington name. To ensure consistency and continuity among offices, White developed an electronic library of forms and art that was distributed to each Barrington office.

▲ The same style of illustration in the capabilities brochure is used in each of the six practice group brochures. Colors and type are consistent and the Barrington "B" appears boldly on every piece.

▼ The capabilities brochure features dramatic full-color illustrations that reinforce Barrington's expertise in providing solutions for its clients.

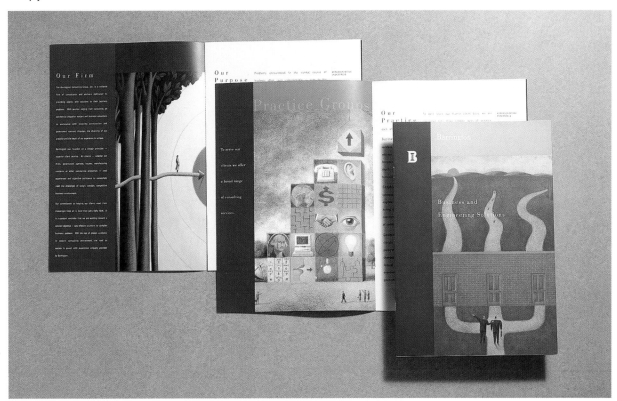

ADDITIONAL SOLUTIONS

To ensure consistency and continuity among offices, White also developed an electronic library of forms and art that was distributed to each Barrington office. White created the templates on a Macintosh and then had them converted so they could be used on Barrington's PC system. He also developed a set of guidelines stipulating type specs, paper, color and the correct application of the new identity system. Now, every office uses the same memo forms, letterhead and even facsimile cover sheets.

Meggison recalls that in his recommendations, White was adamant about consistency of presentation. "Each office was doing its own thing and that put us at a competitive disadvantage. He really gave us insight on that."

He adds that the Barrington staff and its clients are extremely impressed with the new identity system. "The design of the materials consistently reflect the image we want to project," he says. "And White's research and insight on our business and our industry have really helped us focus on our goals and what we need to do to meet them."

Without the research, which cost about $13,500 and was billed as marketing research to Barrington, White says he would have been working in the dark. "If we had not conducted the research, we would never have known what their likes and dislikes were," he says, adding that there were a lot of people involved in approving every phase of the design and many people to please. "You really need to investigate who the end user is. It's a basic marketing principle and a vital part of the design process."

PROJECT CREDITS
ART DIRECTION: John White
DESIGN: Jamie Graupner

CHAPTER 12 GALLERY

CORPORATE IDENTITY PROJECTS

GEOCAPITAL CORPORATION

DESIGN STUDIO: Mike Quon Design Office, Inc.,
New York, NY
CREATIVE DIRECTION: Mike Quon, Elliot Berd
ART DIRECTION: Mike Quon
DESIGN: Mike Quon, Erick Kuo
COPYWRITING: Robert Minkoff
CLIENT REPRESENTATIVES: Wilma Engel, Irwin Lieber,
Barry Fingerhut

In the highly competitive financial services business, it's difficult for a midsized investment and money management company to distinguish itself from large, deep-pocket competitors. But New York City-based GeoCapital Corporation has been able to strengthen its position in the market through a redesigned corporate identity system that evolved from a systematic analysis of competitors' materials.

GeoCapital is a midsized money management firm that primarily serves institutional investors and high net-worth individual investors. The company has been in business for about twenty-five years but had not developed a comprehensive capabilities brochure. They approached marketing and design consultant Elliot Berd, who has consulted with a number of money management firms, and designer Mike Quon to design a marketing brochure out of which grew a complete corporate identity system.

In developing the capabilities brochure, Berd, Quon and client representative Wilma Engel collected samples of marketing materials from nearly three dozen competitors. They also interviewed key personnel at GeoCapital to determine the image the company wanted to convey and the strengths they wanted to emphasize. "We kept a list of words that came up during interviews and meetings that described the company; words like responsibility, ethics, quality and stability," Quon says.

The words are represented in the brochure by contemporary, yet simple images of classic architectural columns, logarithmic growth spirals and growth trees. Complex financial and investment information is broken into easily digestible blocks of copy set off with screens, boxes and punchy subheads. To emphasize GeoCapital's positioning as a quality-oriented, responsible and conscientious company, the design program was expanded to include all communications materials. The outdated and amateurish logo was replaced with a strong geometric version that exudes a solid, methodical and analytical approach to managing money.

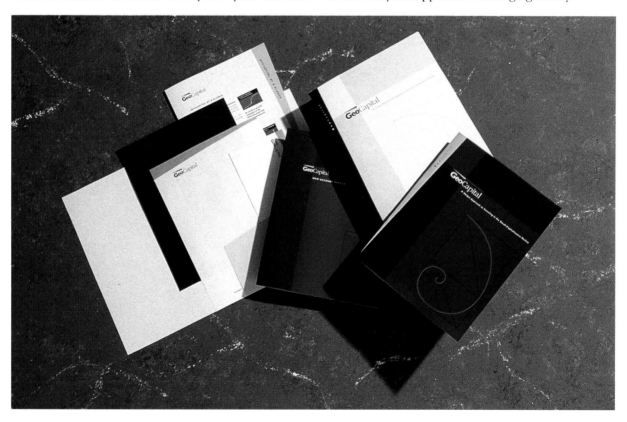

JAMBA JUICE

DESIGN STUDIO: Hornall Anderson Design Works,
 Seattle, WA
ART DIRECTION: Jack Anderson
DESIGN: Jack Anderson, Lisa Cerveny, Suzanne Haddon
ILLUSTRATION: Mits Katayama
COPYWRITING: Suky Hutton

Jamba Juice is a San Luis Obispo, California-based maker of juice beverages. Its products are sold in Jamba Juice stores. The company called on Hornall Anderson Design Works to develop an overall identity and trade dress that would communicate the fact that Jamba Juice is the authority on juice and nutrition.

The design team spent two full days at Jamba Juice's "Juice University," learning about the company, its culture and the market. They sampled all products and visited a Jamba Juice store where they identified the typical buyer of the products and saw firsthand how the products are displayed and sold.

To communicate the objectives, the design team used a palette of bright colors that appear throughout the stores and in collateral materials. The typefaces chosen, Bembo and Meta, are friendly looking fonts that are easy to read. Illustrations convey the nutritional value in the drinks and at the same time, connote a sense of fun. There was a positive overall reaction to the new corporate identity from both the client and the stores' clientele.

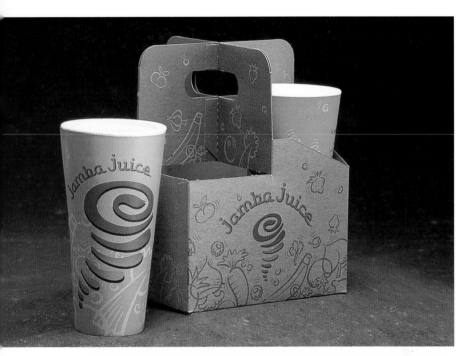

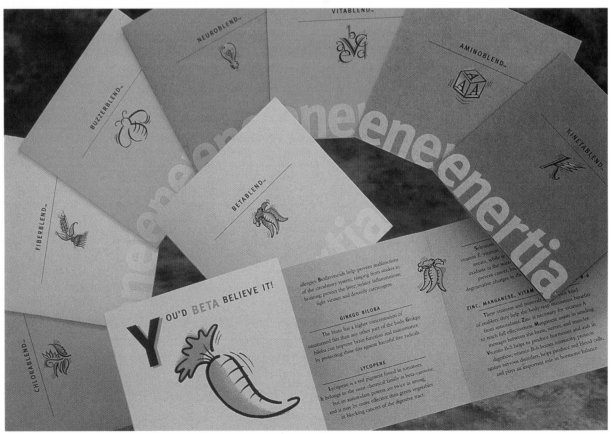

THE EDMOND-HOWARD NETWORK

DESIGN STUDIO: plus design inc., Boston, MA

ART DIRECTION: Anita Meyer

DESIGN: Anita Meyer

PRODUCTION MANAGEMENT: Pinpoint Incorporated

BIOGRAPHER ILLUSTRATOR: Nancy Januzzi

TYPOGRAPHER: Anita Meyer

PRINTER: The Smith Print Inc.

FOIL STAMPING: McEmbossing Inc.

PAPER: Letterhead, Note and #10 Envelope: French Construction Whitewash 24lb. Text; Business Cards: French Construction Whitewash 100lb. Cover; Business Card Holder: Adhesive Library Pockets; Folder: Red Classification Folders

The Edmond-Howard Network is a Roswell, Georgia-based company specializing in management consulting in the wireless communications industry. The wireless industry is constantly growing and changing; consequently, The Edmond-Howard Network wanted to position itself as a leader in providing clients with a working knowledge of this innovative industry.

In developing a corporate identity for the Edmond-Howard consulting team, plus design inc. first prepared a marketing and design brief. This detailed report delves into the company's current operations and its plans for future growth. It profiles the target market and current clientele, and defines the wireless communications industry and its primary distribution channels. It also explores how the principals plan to grow the company and defines the services the company wants to provide in the future. Further, the brief lists words and visual concepts that describe Edmond-Howard's service and training as well as the wireless industry, which are communicated through the corporate identity. *Intelligent, experienced, user-friendly* and *networked* are descriptive words that effectively link The Edmond-Howard Network identity to the broader visual concepts of *typographic innovation, non-corporate, simplicity* and *clear definition.*

The final design is based on the concept of reference books (such as dictionaries and encyclopedias) to emphasize The Network's role as the definitive source for wireless communications consulting. Semicircular finger tabs reflect the character of classic reference materials while the paper stock, fonts and layout maintain a contemporary quality. Also, the system is cohesive yet flexible in its design to allow for changes and adaptations to be made as the industry transforms with time and technological advancements.

IOMEGA CORPORATION

DESIGN STUDIO: Fitch Inc., Worthington, OH
ART DIRECTION: Jaimie Alexander
DESIGN: Jaimie Alexander, Carolina Senior, Kate Murphy,
 Eric Weissinger, Paul Lycett, Kerry Larimer, Sarah Spatt

When Roy, Utah-based Iomega Corporation, a manufacturer of removable data storage products for computers, embarked on a major corporate repositioning strategy, they joined forces with the designers at Fitch to develop a new corporate identity as well as an overall communications and product development strategy.

When research on the category of removable data storage began, the joint Fitch/Iomega team discovered that potential users were basically ignorant about the concept of removable mass storage and they weren't too interested in finding out about it. After doing market audits to understand the competitive environment, researchers spoke with individuals and groups about their storage preferences and needs. In addition, home and office work spaces were audited to understand how people were actually managing their information.

The research indicated that consumers think of their information not as "data," but as something very personal. Further, data storage products could be thought of as tools to capture, organize, share, move, manipulate, create and protect their personal and business "stuff."

At a workshop in the mountains of Utah, key players from Iomega's marketing and product development groups and members of the Fitch design team met to discuss positioning concepts. They concluded that to meet consumer needs, Iomega would develop new products at very reasonable price levels that would be powerful, compact, easy-to-use and personal.

Three new products were designed. The drives bring style and character into a work space while meeting users' real-world demands of creating, organizing, sharing, transporting and protecting their electronic "stuff" easily, safely and securely.

In developing the corporate identity and packaging concepts for the products, the designers developed an identity that plays off the Iomega name in a bold, uncomplicated fashion. A dynamic packaging system was designed featuring direct, nontechnical, easy-to-understand language. The new products reach a wider consumer market and have established Iomega in retail channels of distribution and developed brand awareness at the consumer level.

HAL APPLE DESIGN, INC.

DESIGN STUDIO: Hal Apple Design, Inc., Manhattan Beach, CA
ART DIRECTION: Hal Apple
DESIGN: Alan Otto
DESIGN ASSISTING: Jason Hashmi, Jill Ruby,
 Andrea Del Guercio, Rebecca Cwiak
ILLUSTRATION: Hal Apple, Alan Otto
COPYWRITING: Jamie Apel
PHOTOGRAPHY: Jason Ware

In developing this new identity program for his design studio, Hal Apple surveyed existing clients and reviewed scores of samples collected over a seven-year period of business—pieces used by other design firms, agencies and PR firms. Apple questioned clients about his current letterhead system and the image it projected, some of his new business pieces and even the name of his company. He also asked clients what they thought of competitors' pieces.

He and his design team then reviewed sample pieces for ad agencies, copywriters, PR firms and other design studios. They read books on promotion, including Ed Gold's book on successful design firms, and other publications that covered how to manage growth and operate a design business.

The resulting system includes an introductory mailer with an apple-cinnamon tea bag and a series of case studies on the studio's work inserted in a chocolate brown folder embossed with a small apple.

Apple says response to the new materials has been "tremendous." The marketing techniques employed heavily influenced the final design. "We designed pieces that weren't simply a printed version of our portfolio," he says. "They've helped position our company in the minds of clients as being respected in the industry."

BRANDING

A brand is a name, term, icon or symbol that represents a product or service, or even the supplier of that product or service. For many companies, their brand(s) are their corporate identity. For example, Philip Morris might be best known for its Marlboro brand of cigarettes, Anheuser-Busch for its Budweiser brand of beer and the Procter & Gamble Company for its Crest brand of toothpaste or its Tide brand of laundry detergent.

Developing a brand identity involves perception and positioning.

David Arnold, in his book *The Handbook of Brand Management*, writes: "Branding begins and ends with the perception of the customer." Perceptions are formed on the basis of relevance, benefits and just plain old heartfelt emotions. What salient attribute does the product or service have that makes it of relevance to a customer? What benefits or value does it provide? What feelings or emotions does it provoke?

Positioning is how a company presents a brand to consumers. Each interaction and experience a consumer has with a brand must communicate the brand's message and the value, benefit or relevant attributes it offers.

HOW TO DEVELOP A BRAND POSITION

Arnold lists four criteria that should be applied in developing a brand position:

1. The position must be salient to customers. It must focus on the product or service's use and relevance to the consumer.

2. It must be based upon the brand's strengths. Is it the biggest? The strongest? The best? If it's not, don't think you can fool consumers into believing it is.

3. It should distinguish the brand from its competitors. Communicate clearly the values and benefits the brand offers over its competitors.

4. It must be communicable. If the brand's message or personality is too complex, it can intimidate consumers and force them to look to other brands.

Understanding perception and positioning are key to building a brand identity. For the brand to be successful, Arnold has established the following criteria:

1. The product or service must deliver functional benefits that meet the market's need at least as well as the competition. A brand will not be successful if the product doesn't perform and doesn't meet customer expectations.

2. The brand should elicit loyalty among consumers and inspire them to believe that it will provide them with intangible benefits beyond the product or service itself. Getting consumers to associate the brand with values over and above the mere physical attributes of a product or service is key to building brand loyalty.

3. The various benefits of a brand must be communicated consistently and developed into a brand "personality." Consumers should always clearly understand the brand's message and positioning.

4. The brand's values must meet consumer wants. And what consumers want changes constantly. The brand must consistently evolve and change according to what consumers want.

Primo Angeli Develops Brand Identity for Quantum

PROFILE: PRIMO ANGELI INC., SAN FRANCISCO, CA

FOUNDED: 1968, by Primo Angeli

EMPLOYEES: Forty, including a creative team of twenty

SERVICES: Marketing and communications design, including product ideation, name generation, structural design, brand identity and packaging design, corporate and retail identity, new media design, environmental retail graphics and signage

MAJOR CLIENTS: Bordens, Chesebrough Pond's, Frito-Lay, General Mills, Safeway Stores, Coca-Cola USA, Coors Brewing Company, G. Heileman Brewing Company, Miller Brewing Company, Banana Republic, Mattel Toys, Eastman Kodak, Universal Pictures, Hyatt Hotels, Eddie Bauer Stores, Dunkin' Donuts Inc.

Quantum Corporation, based in Milpitas, California, is a leading supplier of hard disk drives and other information storage devices. It is recognized by computer manufacturers as a leading designer of quality data storage products. When the company decided to expand its offering from the manufacturing arena to the retail level, it called on San Francisco-based Primo Angeli Inc. to develop a brand identity and strategic direction for the product. In selling to computer manufacturers, Quantum had simply packaged its drives in plain cardboard boxes. The move to retail necessitated not only the design of new packaging, but also the creation of a branding program that would blossom into a full corporate identity program for the company.

"This was the first time Quantum would compete at the retail level," explains Jim Goodell, vice president of marketing for Primo Angeli. "And, we had

The design team developed branding guidelines that detail how the Quantum logo is to be used. The Quantum logotype and its tagline, "Capacity for the Extraordinary" are always to be shown together.

a product that had little recognition among consumers in the retail channel. The challenge was to get people to view storage as a vital part of their computing capabilities and to look to Quantum for the solution."

Quantum's director of marketing communications, Doug Howatt, says several factors motivated the company to make the move to retail: "We felt retail would give us a better idea of what our distributors are doing. And it would build visibility and recognition among general consumers." Plus, he says, selling the products in a retail environment would provide Quantum with direct knowledge on why customers buy, or don't buy, certain data storage products.

RESEARCHING THE MARKET

In order to understand the selling environment for data storage products, the Primo Angeli design team conducted a competitive audit. They visited various retail establishments and observed how other data storage products were displayed and presented. They conducted random customer interviews at retail sites to determine product and name recognition and to help identify buying habits. They gathered information on the market in general from various online services and through interviews with Quantum's management.

The information was compiled in a report of findings. Generally, Goodell says, the research indicated that while there was some recognition of the Quantum

name and brand among customers, there was still a lot of confusion.

In terms of presenting the product, the team found that there was a real opportunity for a dynamic packaging system that would immediately grab the shopper's attention. "What we noticed was that the packaging design for similar products was not real sophisticated," Goodell says. "But we think that's what the consumer is looking for."

From management interviews, they concluded that Quantum was basically changing the way they do business. They wanted to get themselves in the forefront of peoples' minds and position the product as the customer's storage unit of choice.

DEVELOPING A POSITIONING STRATEGY

At this point, you might expect that the Primo Angeli team had enough information and market research in their hands to develop a successful brand identity for Quantum, but they weren't ready yet to start designing. Instead, they implemented another research tool to help them precisely define a branding strategy and product positioning.

They call this tool PositionAccess. It's a method for building visually and expressing a range of potential brand positionings and, according to Goodell, clarifying the direction of the design for both the client and the designer. "So many times in the past, we had a client

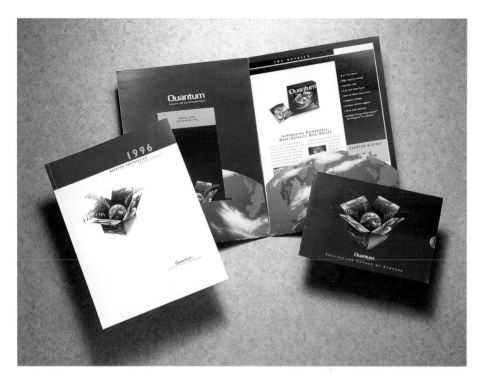

The open box with the globe coming out of it has been adopted as a corporate icon. It now appears on Quantum's annual report, corporate brochures, website and data sheets.

come to us with a written brief or document that outlined what they wanted," Goodell says. "We'd then spend two or three weeks in development and design only to find out that our interpretation of the written word was not the same as the client's."

MAKE SURE YOU'RE ON THE SAME WAVELENGTH AS YOUR CLIENT

That led the company to develop the PositionAccess procedure. It's a two- to four-week process that involves creation of visual cues assembled on 16" x 20" boards, each of which identifies a possible brand positioning.

The visual cues are based on the client's initial ideas for the brand's positioning and the report of findings. They consist of lifestyle graphics, colors and other photographic images that are tied to a particular positioning theme. On each board, there is supportive copy that reinforces the theme.

For Quantum, Primo Angeli designers developed six boards. On one board, they focused on Quantum as a storage partner, using illustrations and photos of a tree, street signs and other images related to information and direction. Another placed emphasis on Quantum enabling the consumer, with images of gaining access to a world of information. The boards were presented to Quantum's branding team, which consisted

of Quantum management, the company's advertising agency and public relations people.

Members of the team mixed and matched visual cues and commented on what they liked and disliked on each board. Howatt says that PositionAccess was a very powerful tool in the branding strategy.

"We had come up with a visual manifest expressing management's marketing goals," he says. "The designers were able to translate that into visual imagery. They had a great way of taking language and turning it into visual cues everyone could relate to."

REACHING AGREEMENT ON A THEME

Goodell says the theme of Quantum as a partner who empowers and enables was a hit. "They thought it stimulated the consumer to identify the product as one you think about whenever you're shopping for peripherals, rather then something you buy only when you run out of memory."

Once there was agreement on the general positioning, Primo Angeli designers went through a design exploration stage, in which they created a range of brand identities that could support the positioning theme. The designs vary significantly but the idea of Quantum as the storage partner for the future is prevalent in all of them.

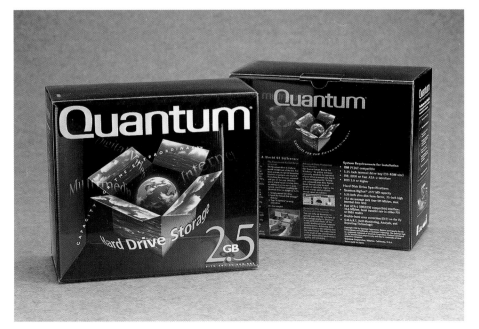

Packaging for the Quantum brand features a box with a recessed panel that has a clear acetate sheet that slips over it. It appears as if you're looking through a screen, creating depth and implying maximum storage. A globe illustration lends to the worldly, futuristic vision and reinforces the ideas of mass storage and having the world at your fingertips

THE DESIGN SOLUTION

What they ended up with is a very dramatic design. The unit is packaged in a recessed box with a clear acetate sheet that slips over it, so it appears as if you're looking through a screen, creating depth and implying maximum storage. A globe illustration lends to the worldly, futuristic vision and reinforces the ideas of mass storage and having "the world at your fingertips." Multimedia, Internet access and the digital revolution are all embraced in this global icon. A tagline of "capacity for the extraordinary" further supports the idea.

Designers also developed a set of branding guidelines that establishes how the Quantum logo and brand is to be used. For example, the Quantum logotype is part of a unit with its tagline; the two are never to be shown separately. In addition, colors, typefaces and other distinguishing characteristics are all spelled out.

On the package, the Quantum name is placed boldly in a prominent position, as is the storage capacity. The ease of installation was also a key message that was presented on the packaging. A checklist on a side panel and a pictorial fast-start installation guide on the back panel reinforce Quantum's "enabling" powers. Warranty information and an 800 number to call for assistance appear on the other side panel.

Howatt says the design on the box has become an icon for Quantum's retail program. Buttons, T-shirts, mobiles and other promotional pieces sport the design. And the open box with the globe coming out of it has been adopted as a corporate icon. It now appears on Quantum's annual report, corporate brochures, website and other collateral.

According to Howatt, Quantum expects less than 10 percent of total sales to be generated by retail, and it's still too early to report any measurable results of the retail program. "But the packaging has already had a noticeable impact on our recognition in the marketplace. Retail salespeople have shown a real interest in the product. Getting past their 'boredom' is a challenge. We've been able to establish our product through the packaging and that's helped us to actually get on the shelves."

PROJECT CREDITS
CREATIVE DIRECTION: Primo Angeli
ART DIRECTION: Brody Hartman, Richard Scheve
DESIGN: Philippe Becker, Nina Dietzel
ILLUSTRATION: Matthew Holmes

BRANDING
PROJECTS

PENCILS FOR
PENTECH STUDIO

DESIGN STUDIO: Sayles Graphic Design, Des Moines, IA
ART DIRECTION: John Sayles
DESIGN: John Sayles
ILLUSTRATION: John Sayles
COPYWRITING: Wendy Lyons

To boost back-to-school sales for Red Bank, New Jersey-based Pentech Studio's line of Cool Art school supplies, Sayles Graphic Design developed this lively, energetic Leadhead brand of pencils. Consumers buy pencils year-round but back-to-school is the peak shopping season. As part of its back-to-school marketing program, Pentech wanted a brand that would jump off the shelf at an audience of teenage shoppers.

The concept for Leadheads evolved from designer John Sayles' visits to local discount department and office supply stores to study the competition and their displays of pencil products, and a thorough review of the client company's past promotions for various brands.

The end result was the Leadhead brand, which features bold figures, vivid colors and "head-banging" copy reminiscent of the popular movie *Wayne's World*.

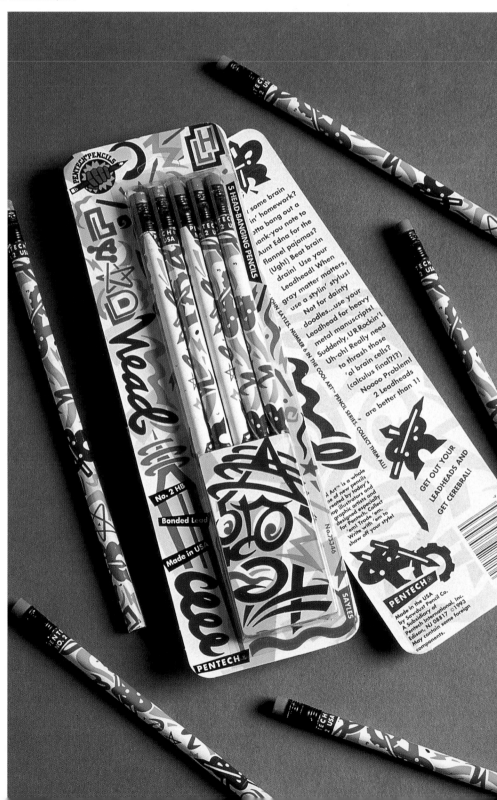

HUSH PUPPIES SHOES

DESIGN STUDIO: Fitch Inc., Worthington, OH
ART DIRECTION: Jaimie Alexander
DESIGN: Paul Westrick, Joanie Hupp, Sandy McKissick
RESEARCH: Mandy Putnam

Hush Puppies is the largest division and most recognizable brand of Wolverine Worldwide. But in recent years, the brand had become tired, with little or no appeal to younger consumers. Hush Puppies management turned to the designers at Fitch to reposition the brand so that it appealed to all age groups, and to identify the brand positioning for a children's line of footwear and apparel.

Fitch conducted retail store audits to determine packaging, communications and merchandising requirements of the retailer as well as to assess the strengths and weaknesses of competitive brands. They developed concepts for a flexible, informational and promotional merchandising system to encourage customer purchases at the point of sale. The concepts were tested through multiple one-on-one interviews with consumers and footwear retail executives. Positioning statements were also tested. For Hush Puppies Kids, a team of market researchers and communications designers worked closely with a Hush Puppies management team to define the product offer and "line logic," appropriate channels of distribution and pricing strategies.

Upon Fitch's recommendations, three lines of adult footwear were developed: Casuals, Outdoor and Comfortable Dress. Each line communicates an individual personality, but is linked with the new Hush Puppies image through use of enhanced identity elements, such as color, texture and form, and of course including the renowned basset hound. A new packaging system for the products was developed to prevent damage to shoe boxes in the storeroom. Color, texture and typography give a warm and approachable feel to the products, and for Hush Puppies Kids, the packaging and communications materials are linked with the adult footwear lines through these same elements.

Hush Puppies credits the brand repositioning with a 190 percent increase in revenues after its introduction to the market.

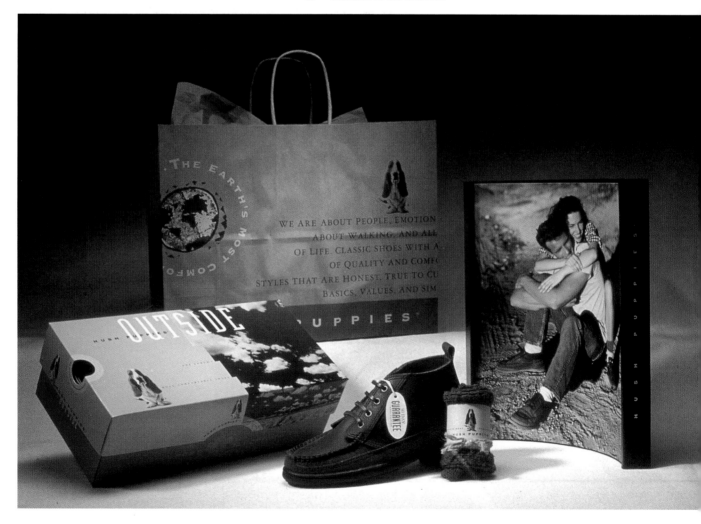

FICTION NOW MAGAZINE

DESIGN STUDIO: Mike Salisbury Communications Inc.,
 Torrance, CA
ART DIRECTION: Mike Salisbury
DESIGN: Mary Evelyn McGough
ILLUSTRATION: Mary Evelyn McGough,
 Mike Hand

Francis Ford Coppola is probably best known for moviemaking. But he's also publisher of a new magazine featuring short stories that have the potential of being turned into motion picture screenplays. Coppola conceived the publication, named *Fiction Now*, out of frustration over an art form that he feels has become stale. Short stories, he contends, are more conducive to being transformed into riveting screenplays than traditional formatted scripts. His goal is to turn at least one story a year out of the thirty or so that are featured in *Fiction Now* into a screenplay.

He worked with Mike Salisbury Communications to develop a look and identity for the publication that would attract quality writing. Salisbury conducted personal interviews and surveys—primarily at bookstands—of readers, writers and editors of similar publications, to determine what would make *Fiction Now* stand out among the forty or so competing publications. What

the design team ended up with is a highly stylized, newspaper-style magazine. In addition to great short fiction, each issue features the design talents of a different artist, photographer, designer or even architect. "This makes the design as important as the writing," Salisbury says, "and gives the impression of an entire creative production."

K2 SKIS

DESIGN STUDIO: Hornall Anderson Design Works, Inc.,
Seattle, WA
ART DIRECTION: Jack Anderson
DESIGN: Jack Anderson, Mary Hermes, David Bates, John
Anicker, Denise Weir, Jani Drewfs

Because graphics are a main factor in the successful marketing of skis, K2 Corporation in Vashon, Washington, works closely with a design team from Hornall Anderson Design Works to develop each season's look. Earlier in the ski craze, most ski manufacturers implemented a similar appearance for their skis, using color palettes consisting of a white ski base with black, blue or red accent colors. As younger skiers began making up a larger part of the market and fashion trends in Europe began influencing what people wore on the ski slopes, K2 took the lead in adopting a look for its products that fit the times.

That's where the expertise of the Hornall Anderson design team comes in. Each season begins with a study of which colors are hot for that year. Different color combinations and, in some cases, different graphics, are produced for K2's largest markets—American, Japanese and European skiers. Within those markets, K2 manufactures skis for different levels of skill, ranging from beginner to competitive, and the colors and graphics are developed accordingly. Because colors and graphics look different on the snow than they do in a retail environment, the graphics are developed to work well in both settings.

CHAPTER
14
PACKAGING

Consumers are suckers for a neat package. "Packages are sometimes called 'silent salesmen,' but what they really do is seduce," writes Ellen Ruppel Shell, codirector of the graduate program in science journalism at Boston University, in a recent issue of *Smithsonian* magazine. "They transform ordinary things—like soap or hair spray or baby powder or muffin mix—into objects of desire. They make us hungry for things we don't need, even for things we don't want. In the eight seconds or so that it takes to choose a laundry detergent or frozen pizza, the package must scream or whine or purr or whisper its message of good taste or cheapness or strength or luxury, loud and clear enough to grab our interest."

Packaging Sells

Indeed, many marketing strategists believe that people don't buy the product inside, they buy the packaging—especially if they're buying the product for the first time. And, if it's a really great package, they'll buy the product again, says Brad Hammond, a professor in industrial design at the University of Cincinnati and the designer of packaging for products like Liquid Tide, Mr. Clean, Comet and Crest toothpaste.

The package designer—and that includes those who engineer the package and design the labeling—can then be the impetus to product sales. That alone forces the designer to also wear the hat of marketer. "Designers work for marketing people and are sup-posed to develop solutions that are sensitive, imaginative and creative," Hammond says. But the solution can only be derived from a complete understanding of the market that includes evaluation of competitors' products, analysis of consumer preferences (which normally entails testing, surveys and interviews of end users), and recognition of the product's goals and objectives .

Designer Involvement— It Pays Off

Hal Apple of Hal Apple Design (see following case study) says that a lot of clients do not expect a high level of market research from their design studios. But, he adds, "It's often up to us (the designers) to point out that it should be done. It shows the client that you have a deep interest in their business and that you want to understand it. It becomes difficult for the client to lock you out if you can show them that your marketing effort will result in a design that takes less time and costs to develop and thus, lower costs in the long run."

Mark Rexroat, former marketing manager of the School and Office Products Division of Mead Corporation, agrees, adding that it's not enough to be a great designer; you have to contribute marketing insight and expertise. "In the realm of marketing," Rexroat says, "the earlier design is involved, the better off you are. I think marketing people are making designers their partner in the early stages of the process. Those designers who have marketing skills and knowledge will have an advantage over those who don't."

CASE STUDY

Hal Apple Redesigns Packaging for Mead Academie Art Papers

PROFILE: HAL APPLE DESIGN, INC., MANHATTAN BEACH, CA

FOUNDED: 1993, by Hal Apple

EMPLOYEES: Eight, including principal and designer Hal Apple; two designers; one design, production and computer manager; one business development manager; two administrative employees; one contract designer

SERVICES: Strategic marketing design, communications planning, packaging programs, naming, website design and multimedia

MAJOR CLIENTS: Sony, MGM, Disney, Trimark Interactive, Davidson, Skechers footwear and clothing, Los Angeles Convention and Visitors Bureau, Mead Corporation

FORMAL MARKETING TRAINING: Apple, one of the staff designers and the company business development person have taken marketing and business classes at the undergraduate level.

When the School and Office Products Division of Dayton, Ohio-based Mead Corporation began to reevaluate its Academie line of art papers, it found—thanks to designer Hal Apple—that some subtle packaging changes were all that was needed to boost sales of the twenty-year-old brand.

Mead is a major manufacturer of quality papers. Although its School and Office Products Division represents a small portion of the company's overall sales, products like the Academie line have created high awareness of the corporation as a whole. You'd be hard-pressed to find an art student past or present who doesn't instantly recognize Mead's familiar Academie Book of Colors product with its multicolored band along the bottom.

Apple enlisted the help of his sister and a New York-based graphic designer to visit stores and observe competitors' products, point-of-purchase displays, the product presentation, retailing environment, prices and so on. Between the three of them, they visited roughly twenty-five stores.

Academie products were some of the first art supplies available through mass market channels like Kmart, Wal-Mart, Target and so on. "For a long time, the products were virtually unchallenged in the mass market," says Mark Rexroat, former marketing manager of the School and Office Products Division and now brand manager for The Disney Store, Inc. in Glendale, California. Art supplies and papers were sold primarily through art stores and other specialty shops. "The Academie brand gained a strong presence and it came to be defined more by its packaging than by any marketing support."

DEFINING THE PROBLEM

But as more mass market retailers opened their doors and specialty retailers started honing in on traditional mass market customers, competition among art and school products suppliers intensified. Although the

Academie products were still showing moderate gains in sales, its competitors were gaining market share. Retailers and the Mead sales force attributed the loss in market share to Academie's old look as compared to the more contemporary look of its competitors' products.

Mead enlisted the support of designer Hal Apple to develop the brand, primarily through its packaging, to the next level.

Apple had worked with Mead on other projects and had impressed them with his strategic, analytical approach to projects for other companies including Texas Instruments and The Container Store. "I think these projects exhibited that I was aware of the client's overall communication objectives," Apple says.

Rexroat adds: "Some people just think the solution to something like this is to redesign without applying any thought process on what's working or not working with that brand." Apple's approach was to tear the

brand apart and rebuild it piece by piece into a stronger, more strategic product line.

STUDYING THE MARKET

In the first phase of the project, Apple spent about a month doing informal research on the product category. He collected Mead papers and competing products and analyzed the messages they were communicating on their packaging. He visited stores (primarily in Dayton where his business was based at the time) and photographed how the products were displayed and who was buying them. He spoke with retailers and store clerks to get their thoughts on why the products are displayed the way they are and what display problems they encountered with certain types of products. Store people also provided insight on why customers were buying the products and how they were using them.

Apple also enlisted the help of his sister (whose job required her to travel quite a bit in the South) and another designer in New York to do store checks. Apple paid them a couple hundred dollars each to visit stores and observe competitors' products, point-of-purchase displays, the product presentation, retailing environment, prices and so on. Between the three of them, they visited roughly twenty-five stores.

Apple created a number of schematics that summarized his analysis of the products. One showed who buys the different types of paper products, who actually uses them and for what purposes they use them. Another compared prices of the various brands, and a third illustrated the "business environment." Apple and Rexroat refer to this schematic as a chessboard where the various players in the product market were placed in terms of price and the customer category to which they most related.

FORMULATING POTENTIAL PACKAGING STRATEGIES

Based on his initial observations, Apple also developed a list of marketing considerations that addressed many issues, such as the message on the packaging that states only which media to use on the paper but not the variety of uses the paper may have. He pointed out that the market was saturated with low-end construction paper but that high-end papers are not seen in mass market

Apple created a number of schematics that summarized his analysis of the products. *Top:* This schematic shows who buys the different types of paper products, who actually uses them and for what purposes they use them. *Middle:* A second schematic compares prices of the various brands. *Bottom:* A third is what Apple refers to as a "chessboard," where the various players in the product market are placed in terms of price and the customer category to which they appeal most.

For the color palette testing of the focus groups, Apple removed all type and graphics from Academie's existing packaging and also developed modified palettes of the existing color scheme. Blocks were used to indicate the color of the type that would appear on the packaging.

channels, only specialty art supply stores. He noted that the product is a destination-based purchase and that rarely will consumers buy it on impulse. He also pointed out that the Academie line packaging and logo has deep equity: "Baby boomers grew up with it. I bought it throughout childhood," he says.

Apple came up with a set of recommendations for the product and the packaging based on his research and observations. His product suggestions ranged from making minor adjustments to the binding on some drawing pads to developing new paper products for changing markets. His packaging suggestions focused

on clarifying the message and making subtle changes to the graphics and the logo of the hand holding the pencil.

He organized his research, observations and recommendations in a thirty-six-page report that he submitted to Mead. "It was really helpful for their marketing people to see as well as their sales force," Apple says. "Before this, they were only looking at numbers—how sales for certain products were going. No one had ever really studied buying patterns and what influences buying decisions." At the behest of Apple, Mead decided to investigate buying patterns even further by conducting focus groups.

GAUGING CONSUMER PERCEPTIONS

Mead contracted with Cincinnati-based Matrixx Marketing Inc. to conduct four age-based focus groups. The age breakdowns were 15 to 18, 19 to 29, 30 to 50, and 51 and over. Each group had eight to twelve members, and each member was required to have purchased a paper product within the last six months through mass channels, such as a Target or Kmart store.

"Our main goal for the focus testing was to find out why people buy paper products and what appeals to them in the packaging," Apple says. He and Mead's Rexroat and art director Marna Henley developed a line of questioning for Matrixx that tested five things: The level of expertise of the person buying, or for what purpose were they using the product; the color palette of the packaging; logo and name recognition; the positioning statement on the packaging; and the type of information that should be included on the packaging. They observed the focus groups through a one-way mirror.

The majority of participants revealed that they categorize themselves as hobbyists, typically at the beginner to intermediate levels, who draw or paint for their own enjoyment. They feel they do not need the highest quality paper to satisfy their hobby needs. Participants in the 15- to 18-year-old group, however, categorized themselves as hobbyists, students (involved in some level of art study) or artists (chose art as a career or had the expertise to create, rather than copy).

For the color palette testing, Apple removed all type and graphics from Academie's existing packaging

and also developed modified palettes of the existing color scheme. These, along with reproductions of competitors' color palettes without the text and graphics, were presented to the focus groups. Blocks were used to indicate the color of the type that would appear on the packaging.

Focus Group Results

The testing found that focus group participants generally preferred the Mead color palettes over any of the competitive color schemes. They responded that the existing Academie colors conveyed a sense of high quality as well as practicality and reliability. They reacted favorably toward the modified Academie color scheme, stating that the new colors indicated an updated, high-quality product inside. Many respondents equated the bright, eye-catching colors used on competitors' products with cheaper, lower-quality paper.

For the logo and name recognition testing, it was found that participants were highly likely to recognize the hand logo and Book of Colors color strip, but were less likely to attach the Academie name to the brand. Apple drew several variations of the hand to test their appeal. Overall, respondents liked the existing rendering better than the others shown but thought it needed some improvement. Many participants responded that they were intimidated by the more elaborate and perfectly apportioned renditions.

Five different positioning statements also were tested. One was artistic in nature, pointing to the widespread use of Academie papers by artists at all levels. Another was technical and explained how the paper is manufactured and tested; one stressed the company's commitment to the environment; one emphasized value; and another was romantic in nature, alluding to the history of art. Participants responded strongest to the statement emphasizing value because of its informative, straightforward approach.

As for the type of information that should be included on the packaging, participants were asked if they wanted to know about the medium most appropriate for use on the paper, its specifications, its applications and who would use it. Of most importance to a majority of participants was an explanation of what the paper could be used for (i.e., watercolors, pencils, pas-

For the logo and name recognition testing, Apple drew several variations of the hand to test its appeal. The majority preferred the current design (shown above) but a significant number of participants also liked rendering #19 (shown at top), which is most similar to the current design.

tels). Respondents also noted that they wanted information to be brief and nontechnical in nature.

Applying the New Marketing Information

"The information we got from the focus groups helped Mead's marketing department understand who was buying the paper and why," Apple says. "We went back to the chessboard and could understand where the Academie brand fit in terms of price, appeal, etc. Based on the results, we felt that we didn't need to move the brand's position much. It just had to be reestablished and strengthened. We felt we only needed to make minor adjustments to everything instead of a major overhaul."

Rexroat adds that the results of the focus group

The final packaging system for the Academie products included a new color palette, slightly updated logo and new typography. The new design is applied to the nearly thirty products in the Mead Academie line. The only product that has not adopted the new design is the Book of Colors because it has such high recognition the way it is.

testing and analysis of other research was "a marketing manager's dream. We were able to conclude that we were already in a good position and that making any drastic changes to the existing packaging could very well be disastrous."

MINOR MODIFICATIONS STIMULATE SALES

Apple adopted a modified version of the color palette and used the cream color for most of the type on the packaging. Since recognition of the hand illustration was so high, it was just slightly modified and kept as a vital part of the packaging. The product information was moved lower on the pads so that shoppers could easily see it displayed flat on retailers' shelves.

He developed a core design and then established guidelines (point sizes, colors, product information and so on) for the nearly thirty products in the Mead Academie line. The only product that has not wholly adopted the new design is the Book of Colors because it has such high recognition the way it is. The guidelines are used by agencies, point-of-purchase and display designers, the sales force and other graphic design-

ers who work on the Academie brand.

Rexroat says that sales for Academie products after the redesign rebounded remarkably after posting only 2 and 3 percent gains during the five-year period before the redesign. "In the first year after the redesign was finished, business grew 22 percent," he says. And, the new packaging combined with the focus group testing results helped Mead salespeople illustrate to retailers the Academie brand's appeal to consumers. A videotape presentation that included the focus group sessions was developed for salespeople to show to retailers. "We could educate retailers on who their consumers were," Rexroat says.

Because of all the research undertaken, Apple was able to address the concerns of Mead salespeople, retailers and the consumer. "The research gave me parameters to use in coming up with the design, and we could cut the whole design process from months to weeks. In fact, we spent more money on research than on design." Rexroat says that Mead spent about $100,000 on research and design. Apple estimates that he was paid between $10,000 and $15,000 for his market research activities.

PROJECT CREDITS

PROJECT DIRECTION: Mark Rexroat, marketing and brand manager of the School and Office Products Division, Mead Corporation
ART DIRECTION: Marna Henley, Ray Denison, Mead Corporation
DESIGN: Hal Apple, Hal Apple Design Inc.
COPYWRITING: Daniel Lee
ILLUSTRATION: Graphica

PACKAGING
PROJECTS

JBL EON PORTABLE PERFORMANCE SYSTEMS

DESIGN STUDIO: Fitch Inc., Boston, MA
ART DIRECTION: Ann Gildea
DESIGN: Kate Murphy, Jennifer Boyle
COPYWRITING: Mark Henson

JBL Professional Group, a division of Woodbury, New York-based Harman International, manufactures and markets products for the fields of broadcast and recording, musical instrument support and sound reinforcement. While best known for its high-end professional speakers and mixers, JBL Pro recognized an opportunity to gain a foothold in the lower end of this market segment. The company approached Fitch to create a lower-priced system, called EON, and the packaging for it.

Fitch conducted research to investigate the needs of users, primarily disk jockeys, schools, churches and musicians. Research consisted of in-field study and analysis, one-on-one interviews with end users, competitive audits and store audits. The research team found that the typical potential user of the new system lacked the necessary technical knowledge to create optimal sound quality. Music stores usu-ally don't have sound professionals available on the sales floor, so they sell according to the consumer's budget and the product's availability, not necessarily according to needs. Fitch also found that JBL is a technically oriented company, unused to servicing the typical, everyday customer. They consistently used technical language in their literature.

JBL and Fitch developed a solution in the form of bi-amp powered speakers and a passive mixer, representing a significant break from the industry standard. This combination creates superior sound without requiring a lot of technical skill. Built-in, ergonomic handles and quality plastic enclosures make the speakers lightweight and easy to carry. Several changes were also made to the mixer board to make it more understandable for nontechnical users and more readable in low-light situations.

The EON name, packaging system and owner's guide were developed to echo the simplicity and integrity of the finished product line. Fitch assessed JBL's global distribution needs and recommended a straightforward, inexpensive packaging system that relies on a few different-sized boxes to hold all the products. Labels are applied to the box depending on the enclosed product and its country of destination. The multilingual owner's guide was written to be easily understood by nontechnical users, and consolidated over one hundred pages of text into twenty-eight pages of concise, user-friendly information.

FOREST PURE BATH PRODUCTS

DESIGN STUDIO: Curry Design Inc., Venice, CA
ART DIRECTION: Steve Curry
DESIGN: Kris Tibor
COPYWRITING: Laura Quick

Chatsworth, California-based Levlad Inc. is a manufacturer of the Forest Pure line of hair, skin and bath products. The line consists of more than twenty products. Hindered by outdated and dull packaging and losing ground to its competition, Levlad enlisted Curry Design to strengthen its position in the market through redesign of its package labeling.

Curry knew from the client that the products are sold primarily at specialty bath and body shops and at health food stores. The market for the products is environmentally conscious and health-conscious consumers. The design team then conducted a comprehensive study of competitive lines and products. What they found was that Forest Pure had high appeal because of its use of natural ingredients and Levlad's commitment to donate a portion of proceeds from sales of Forest Pure products to a non-profit environmental organization.

To illustrate concern for the environment and play up the use of natural ingredients, art director Steve Curry says he envisioned himself in a rain forest. "Then we placed a booth in the forest with natives selling Forest Pure products. We saw the soaps and lotions wrapped in banana leaves and tied with raffia and wild flowers," he says. Out of that concept came a clean label design that features orchids and butterflies. Various types of orchids are used and paired with a product of similar color or scent. For example, a white orchid is used on the labeling for Wild Vanilla soaps and shampoo. For the bottled products, the label's border or background is a leafy tropical forest pattern. The orchid appears to be "tied" to the bottle with raffia, adding sensual appeal.

Curry estimates the marketing research costs for the project at about $5,000. Levlad has received a significant number of sales requests from retailers at the national and international levels.

TALKING RAIN SPARKLING ICE BEVERAGES

DESIGN STUDIO: Hornall Anderson Design Works, Inc.,
 Seattle, WA
ART DIRECTION: Jack Anderson
DESIGN: Jack Anderson, Jana Nishi, Julia LaPine,
 Heidi Favour, Leo Raymundo, Jill Bustamante
ILLUSTRATION: Julia LaPine

When Preston, Washington-based Talking Rain decided to expand its beverage offerings from the club/warehouse environment to other retail outlets, it needed distinct and dynamic bottle and can graphics to distinguish it as a breakthrough leader in the beverage category. To gain an understanding of Talking Rain's new market, designers from Hornall Anderson Design Works studied industry trends and current packaging for bottled water and other beverages. They also conducted a project "download" to specify marketing and image criteria, which was used as a gauge throughout the design development to monitor the effectiveness of solutions.

Using this criteria and information gathered on the industry, the design team developed rough sketches that addressed specific project and image goals. With some refinements to the sketches, a final design evolved that positions the beverages as a premium and unique brand.

Contemporary graphics and typography create a classy, unique look, while the surreal, conceptual interpretation of the fruit flavors distinguishes the brand from competing products that focus on more literal representations of fruit. Products within the line are further differentiated with individual color palettes. The graphics are applied directly to the bottles rather than on paper labels. A gradated frost adds to the "ice" effect. For the cans, an uncharacteristic two-color gradation and line drawings representing the beverage's fruit flavor help them stand out against competitors' cans.

SAKS FIFTH AVENUE GOURMET FOODS AND CANDY

DESIGN STUDIO: Sayles Graphic Design, Des Moines, IA
ART DIRECTION: John Sayles
DESIGN: John Sayles
ILLUSTRATION: John Sayles

When a major national retailer seeks you out to do design work, it's a real compliment. When the design work involves redesigning the packaging for the retailer's line of gourmet foods and candies, it's a dream job. It was for Sayles Graphic Design anyway, whose designers found that the combination of shopping and food made research for this Saks Fifth Avenue project an extremely palatable job.

In developing the design concept, Sayles had to keep in mind the store's clientele, which is characterized as upscale and quality-oriented. The design team visited numerous department and specialty stores to evaluate similar products' packaging and presentation. They were looking specifically for eye appeal and shelf life.

The final design features a dull gold on a cream background that has an elegant and refined feel, with an illustration style that complements the colors.

15

SALES AND MARKETING COLLATERAL

While the skills of a salesperson are usually what closes a sale, the appearance and appeal of collateral material can strengthen the presentation and make an equally powerful impression on a prospective client.

"The design of collateral is very important, whether you're using the piece as part of the live selling presentation or you're leaving it behind," says Jack Criswell, executive director of Sales & Marketing Executives International, a nonprofit professional association based in Cleveland, Ohio. "The salesperson is depending on it to carry a sales message."

In fact, it not only carries a sales message, it conveys the image and personality of the firm, which is important to the prospective client as well as the salesperson. Paul Sherlock writes, in his book *Rethinking Business to Business Marketing*, that the only person or team of persons who can tell a company's or product's story are those who have "looked customers in the eye time after time [and] listened to their needs."

It stands to reason, then, that the writer or designer of sales and marketing communications materials must know that story as well as any person in the company. Sales and marketing collateral are fundamental to most marketing efforts. In some situations, it must do most of the selling itself. In others, it's a supportive reminder to clients of the story you are telling.

HOW TO CREATE EFFECTIVE SALES AND MARKETING COLLATERAL

Sherlock suggests that for sales and marketing collateral to be effective marketing tools for a company, they should contain the following:

- Good presentations of the product or service (photos, illustrations and so on)
- The "story," presented in such a way that it makes people react in some manner
- "Rationalization" aids that help convince the customer to buy into the story
- Technical information that the customer might want to reference (and not want to throw away)
- Information on how to contact the company

This is only a suggested list of requirements. Depending on the nature and purpose of the collateral pieces, you might also include price lists, case histories, testing reports and general company background and history.

Hornall Anderson Creates Collateral

for Retirement Savings Program

PROFILE: HORNALL ANDERSON DESIGN WORKS, INC., SEATTLE, WA

FOUNDED: 1982, by John Hornall and Jack Anderson

SERVICES: Identity, collateral materials, environmental graphics and

sign systems, packaging, promotional graphics, sports graphics

MAJOR CLIENTS: Starbucks Coffee, OXO International, Corbis Corporation,

Darigold Corporation, William & Scott Co., Smith Sport Optics Inc.

FORMAL MARKETING TRAINING: On-staff marketing director

The Frank Russell Company, based in Tacoma, Washington, has provided investment management and consulting services to some of the world's largest companies for more than sixty years. When it decided to expand its business offerings to include employee retirement savings programs—401(k) plans—it worked in conjunction with two research firms and design studio Hornall Anderson Design Works to develop a comprehensive marketing strategy that left no stone unturned concerning the buying behavior of its target audience and the types of communications materials they would respond to.

As the provider and administrator of such programs, Russell's objectives were to clearly define the savings program and then to create a range of materials for the program sponsors (the employers) and for participants (the employees), which its sales force could present to existing clients and prospective ones.

Investment and retirement planning materials tend to be dry and intimidating to the average investor. Russell realized the need to personalize the information if they were going to get participants to join the plan, so developing communications that were warm and friendly was a priority.

They formed a project team that consisted of themselves; market research firms Meridian Research in Columbus, Ohio, and Age Wave in San Francisco; and Seattle-based Hornall Anderson Design Works, Inc.

REVIEWING THE INITIAL FINDINGS

At the launch of the project, art director Jack Anderson says the design team was told that they were all partners in this marketing effort. "We were part of this alliance," he says. "Hornall Anderson's goal was to translate all the information and research done into easy-to-read materials."

Russell had been working with Meridian for two years prior to the inception of the project. Meridian had compiled reams of information on buying behaviors for financial planning products and services through focus groups and intercept interviews at malls, banks, brokerage houses and so on.

"What we found," says David J. Jepsen, manager of Financial Planning and Education for Russell, "was that people are motivated to do some sort of financial planning or buy a financial planning product following a significant life event. They might buy a house, or have twins, or get promoted, or their mother moves in with them, and that triggers them to think about their financial future."

Russell also learned through focus group testing that buyers are turned off by financial planning materials that address them as a "homogenous" group. They respond favorably to materials that recognize individuality and the special needs of individuals during the various stages of their lives.

DEVELOPING A THEME BASED ON RESEARCH

This research was presented and discussed in a series of one-day retreats in which members of the project team developed key concepts about the market. It was from these early meetings that the concept of a "life map"

For the 25 to 35 age group board, Hornall Anderson picked colors, typefaces and images that are indicative of the things "generation Xers" see in their lives.

For the 50 to 65 age group board, traditional images were combined with stylish, upbeat colors and patterns.

The board for the 35 to 50 age group had a more refined, sophisticated look to it. Earth tones and images that connote responsibility and consideration were used.

For the "middle America," or working class board, large type and clearly defined images are set off by lots of white space for an uncluttered, straightforward look.

emerged, says Hornall Anderson designer Lisa Cerveny.

The life map represents a continuum that identifies the various stages of life. The idea grew out of the observation that people are motivated to buy financial planning products by significant events in their lives. It eventually became the central theme of Russell's employee savings retirement program, which adopted the name "LifePoints."

The team also defined three age groups that they felt needed to be addressed in the materials: 25 to 35, 35 to 50 and 50 to 65. "It was clear from the research that we needed to segment the market," Jepsen explains. "Employees don't respond to financial materials that treat them as if they are all alike."

CONSUMER ATTITUDES DRIVE THE DESIGN

Using the research and ideas presented at the retreats, Hornall Anderson set out to do their own research on how the target markets would react to certain images. "We felt we had a good understanding of who Russell was trying to reach," Anderson says, "but we needed to know how best to communicate with them."

Hornall Anderson developed a set of attitude boards to test each market's reactions to certain images and messages. The attitude boards are a unique tool Hornall Anderson created several years ago for a software development company. "The client was quite taken with it," Anderson says, "and so it's become kind of a benchmark in our design process."

For the Russell project, Hornall Anderson assembled four boards, one to represent each of the defined age groups and a fourth that represents a "working class" or middle America category of consumers. Images, textures, colors and type elements that they felt the different groups would respond to were collaged on 64" x 20" boards. A design concept illustrating how all the elements could come together in a single format was also included on each board.

For example, for the 25 to 35 age group board, Hornall Anderson picked colors, typefaces and images

◄ Hornall Anderson developed two sets of comp folders, booklets and brochures to test responses to different formats. One set was typographic in nature, relying on large type and easy-to-follow chunks of digestible information.

A second set of comps relied more on colors, imagery and white space to draw the reader in.

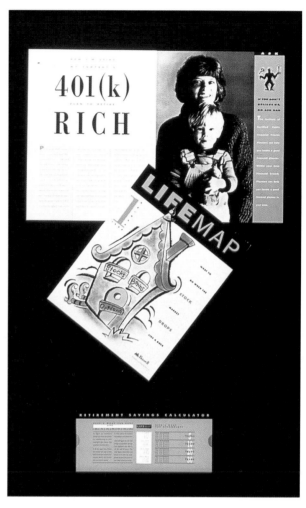

that are indicative of the things "generation Xers" see in their lives. Bright colors, funky patterns and a trendy, geometric look are dominant. Cerveny refers to it as the "MTV" board.

CONDUCTING FOCUS GROUPS TO TEST REACTIONS

The attitude boards along with materials from Russell's competitors were then presented to focus groups organized in cities around the United States. Members of the project team viewed the focus group testing through a one-way mirror.

Focus group participants represented all age groups. They were first shown materials from competitors. While they responded favorably to one set of materials that used bright colors and illustrations, they found them, in general, to be too technical and intimidating in nature.

Then, they were shown the attitude boards. All four boards were set up at the same time and participants were urged to walk around and study them.

Cerveny says participants favored the 35 to 50 attitude board. "They felt it was serious enough, but not stodgy. They hated the word 'ugly' on the MTV board and thought it was too 'light' or flamboyant to appeal to all ages. They didn't like dark or moody colors but preferred muted, softer tones that still indicated optimism. They especially liked the use of large type and white space on the working class board."

After the first focus group testing was completed in California, Hornall Anderson developed two sets of comp folders, booklets and brochures to test responses to different formats. One set was typographic in nature, relying on large type and easy-to-follow chunks of digestible information. The other set of comps relied more on colors, imagery and white space to draw the reader in.

Cerveny says that participants in the focus group testing liked the typographic version and its easy-to-read format, but they also liked the use of white space and color in the other set of comps.

DESIGNING WITH MARKETING INFORMATION AS THE FOUNDATION

Based on the research and testing results, Hornall Anderson designed a package of materials that includes a brochure for the plan sponsor and a kit for participants that consists of the LifePoints brochure, a slide rule to help them with their financial planning calculations and two additional brochures on retirement planning that participants can opt to receive.

Central to the twenty-six-page LifePoints brochure is a three-page foldout of the life map in the front of the brochure. It clearly identifies the three major "tracks" of the LifePoints savings and investment program. The designers focused on images and elements that represent major events, or "life points,"

which occur in various stages of life. For example, the "Beginnings" track, which is a savings/investment program geared to those employees just starting out in their careers, contains images of youth, education and learning. This program is also geared to those who are "starting over," and images of single parenting and divorce are tastefully woven into the presentation.

The "Midway" program, which is designed for employees who have already begun their retirement planning, is characterized by a set of car keys, reading glasses, a classy ink pen and a smiling young family. The "Transitions" track, which is for employees who are completing their financial preparation for retirement, features images of a fulfilling and financially secure future.

The foldout appears as a seamless continuum, but the three tracks are clearly defined by warm color coding and simple explanations that help participants pick the appropriate track for their individual needs. The foldout is followed by three four-page sections detailing each of the tracks. Color-coded tabs are used

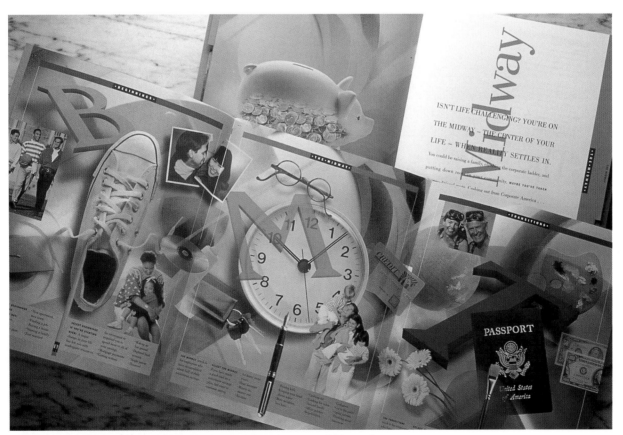

Central to the twenty-six-page LifePoints brochure is a three-page foldout of the life map in the front of the brochure, which clearly identifies the three major "tracks" of the LifePoints savings and investment program.

to identify the tracks. Each section contains short, reader-friendly information that, as Jepsen remarks, "is riddled with references to life events." A questionnaire that helps participants assess their risk tolerance is included in all three tracks.

EXAMINING THE RESULTS

The initial print run for the brochure was 150,000. "Our goal for these materials was to get existing clients to adopt the program and to attract new ones," Jepsen says. "We've been successful on both counts." Jepsen says that Russell's sales force has embraced the LifePoints program and believes the communications materials give them a competitive edge over other companies offering defined contribution plans. "It's really helped us better define our product and it's helped our representatives enhance their relationships with existing clients." In fact, Jepsen points out, Russell has presented the LifePoints program to its two hundred or so existing clients; almost all of them have accepted it and are making it available to their employees.

Jepsen says the marketing effort undertaken for the LifePoints program was one of the most arduous he's ever been involved in. "Working with a design firm that understood our market was critical to the success of the program," he says. "Hornall Anderson has been a good partner and they've helped us develop further the LifePoints program into an umbrella for all our financial planning materials."

Likewise, Anderson says he can't think of another instance where the design firm was so submerged in learning about the client's market and what triggers their purchasing decisions.

"When we started this project, the only preconceived notion we had for the design was that it had to be warm and friendly," he says. "The final design was governed by the buying patterns research and focus group testing of the attitude boards. This research and our involvement in compiling market data really took the subjectivity out of the design."

While many designers would cringe at taking such a methodical, analytical approach to design, Cerveny is quick to point out that in the highly competitive financial services market, design cannot be subjective or based solely on intuition. "Russell had clearly defined who their market was and what their needs are. Our responsibility was to use that data to design materials that would communicate with the target audience. We would not have been nearly as successful in our design if we did not have a very in-depth understanding of their market and if we didn't use that information in developing the materials."

PROJECT CREDITS
ART DIRECTION: Jack Anderson
DESIGN: Jack Anderson, Lisa Cerveny, Suzanne Haddon
ILLUSTRATION: Julia LaPine
COPYWRITING: Frank Russell Company
PHOTOGRAPHY: John Still

SALES AND MARKETING COLLATERAL PROJECTS

SIMPSON PAPER ESTATE LABEL SWATCHBOOK

DESIGN STUDIO: Tharp and Drummond Did It, San Francisco,
 CA/Portland, OR
PROJECT MANAGER: Cheri Edwards, Simpson Paper Company
ART DIRECTION: Rick Tharp
DESIGN: Rick Tharp, Susan Craft, Stan Cacitti
ILLUSTRATION: James LaMarche
PHOTO IMAGE: Tom Landecker
CALLIGRAPHY: Georgia Deaver
COPYWRITING: Charles Drummond
PRINTING: Blake Printery

Paper company swatchbooks are used primarily by graphic designers, printers and marketing people. Traditionally, swatchbooks include samples of the colors and finishes available in a paper line. They might also include a demonstration of how the paper performs in various uses such as multicolor printing, embossing, foil stamping or die cutting. In designing a swatchbook for Seattle-based Simpson Paper Company, whose Estate Label papers are produced primarily for use on wine and beverage containers, the team from Tharp and Drummond Did It could have gone the traditional route and, they say, their client would have been happy.

"But because of our experience designing for the wine industry, we believed there was another important marketing issue that needed to be addressed," Tharp says. "With Simpson being an authority in the wine label paper business, we wanted to position the company in this light." So, the design team suggested using the swatchbook to educate and guide the paper specifier through the process of producing a wine label. They interviewed printers to get information on the performance of label paper on press, and bottling line personnel about the papers' abilities to perform on high-speed bottling lines and to withstand refrigeration and moisture. They also obtained information from the Bureau of Alcohol, Tobacco and Firearms on legal requirements concerning wine labeling.

The information is presented in the swatchbook in a logical, informative manner. The paper swatches themselves are presented unobtrusively, yet are very easy to identify and sample.

Tharp says that after the books became available, customer awareness increased immediately in both the graphics and wine industries. "We were able to position Simpson as the authority in the label paper business."

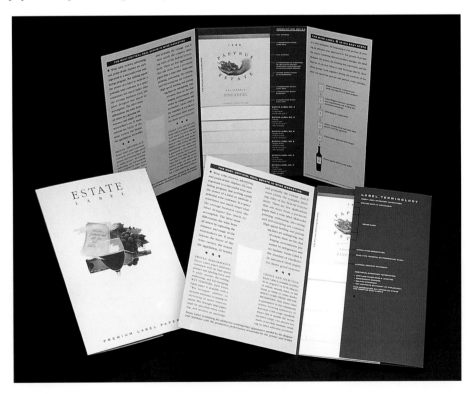

MARKETING COLLATERAL FOR GOOD CENTS ENVIRONMENTAL HOMES

DESIGN STUDIO: After Hours Creative, Phoenix, AZ
PHOTOGRAPHY: Art Holeman

After Hours Creative worked closely with management of Atlanta-based Southern Development & Investment Group to develop a complete marketing program to inform home builders, developers and home building product manufacturers about the Good Cents Environmental Home program—the client's environmentally sound home building program. The objective was to attract them to this national licensing program and to encourage builders to participate in environmentally sound building practices.

As part of the development and design process, focus groups were held in Atlanta, Chicago and Los Angeles to help the client/design team better understand the marketplace and its attitudes about the client's "Good Cents" brand name, the concept of environmental home building, saving energy and preserving natural resources, and designing the home of the future. The team also reviewed existing research, including mail surveys, mall intercepts and phone interviews to define potential markets, market share and any barriers to market entry.

Russ Haan of After Hours says the market research was invaluable in developing the design. "We found that we really had to address three audi-

ences: the home buyer, who wanted to feel their new home was more a part of nature; the home builders, who wanted to be sure the program was easy and efficient to use and would set them apart from their competitors; and manufacturers, who wanted a way to get their products 'endorsed' as environmentally friendly," Haan says. "This provoked the client to redefine their entire marketing approach, from a single licensing strategy to a multilevel approach that included consumers, builders, utilities and manufacturers."

After Hours developed a branding program, direct mail, sales collateral, a sales video, trade show booth and other marketing materials that addressed the concerns of all these markets. Images of construction tools blending dramatically into natural elements, such as water, leaves and grass, accurately convey the client's story. Haan says more than 2,500 builders inquired about the program in the first year after the new materials were introduced and eight national manufacturers signed up for the licensing program.

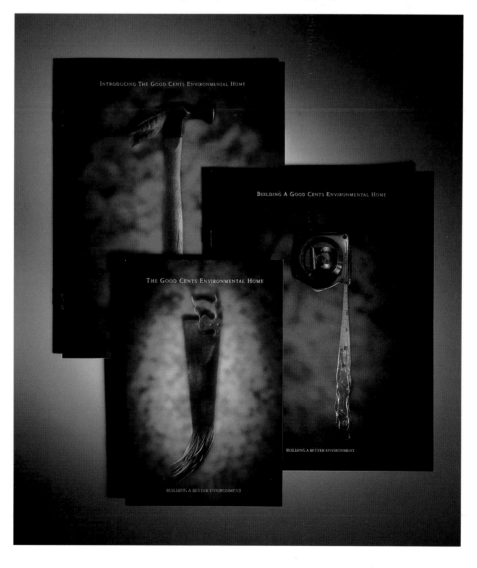

BROCHURE FOR INPOWER, INC.

DESIGN STUDIO: Canary Studios, Oakland, CA
ART DIRECTION: Carrie English, Ken Roberts
DESIGN: Carrie English, Ken Roberts
ILLUSTRATION: Carrie English
COPYWRITING: Maria Miller, Steve Knowles, Bill Swenson

San Francisco-based InPower, Inc. is a developer of human resource management software. Although the company had a good idea of who it wanted to market its products to, it had not developed an effective system for communicating with potential end users. That's when they enlisted the aid of Canary Studios.

"InPower understood that their customers were more than just MIS people. They included human resource professionals who worked with MIS staff to choose products for their software needs," explains Ken Roberts of Canary. The design team conducted phone interviews with end users and found that most HR people were at a loss when it came to understanding the terminology associated with the software, and often felt overwhelmed and belittled by the use of jargon they didn't understand.

Canary's research and understanding of the market's needs drove them to create this intimate, interactive booklet that explains in laymen's terms what HR management software is all about. Illustrations, though rendered on computer, have a hand-drawn style. The vellum overlay sheets and tactile feel of the paper provoke interactivity. The "lexicon" theme helps position the company as an authority on HRMS. "Every aspect of the brochure was meant to give the user valuable information," Roberts says. "We wanted it to be more like a gift. It gives InPower a 'human' feel."

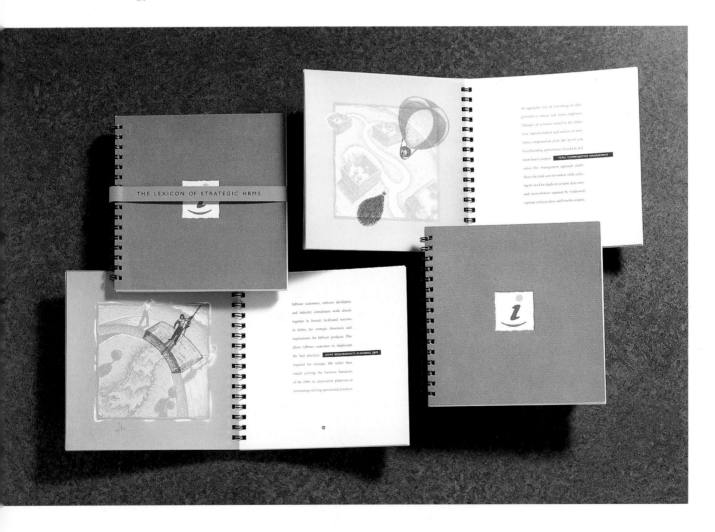

MIAMI VALLEY CENTRE MALL BROCHURE

DESIGN STUDIO: 1•earth GRAPHICS, Troy, OH
ART DIRECTION: Jay Harris
DESIGN: Lisa Harris
COPYWRITING: Mark Palmer
PHOTOGRAPHY: AGI Photographic Imaging

In order to generate interest among retail location scouts, 1•earth GRAPHICS engineered a repositioning strategy for the Miami Valley Centre Mall in Piqua, Ohio, that included a new identity and several key marketing pieces.

Art director Jay Harris says the key to appealing to the target market, which consists of regional and national retail stores and chains, was positioning the mall as a better location for retailers than its competitors—malls located around the country. "We focused our energies on identifying key competitors and researching their strengths and weaknesses," Harris says. The design team reviewed brochures, advertising campaigns and samples of other malls' logos and visited a number of malls in the region.

They developed a contemporary-looking logo that borrows its look from the mall structure itself. An elegant archway that marks an entrance to the mall is reflected in the logo's building icon. A tagline of "The centre of your life" sums up the benefits retailers realize from locating at the mall. The brochure features photos of existing mall tenants and testimonials on the benefits of operating a store there. The design incorporates lively graphics and connotes energy and activity.

Harris says the new brochure has generated a lot of interest from retailers, including one major national chain that has expressed interest in becoming the mall's fourth anchor.

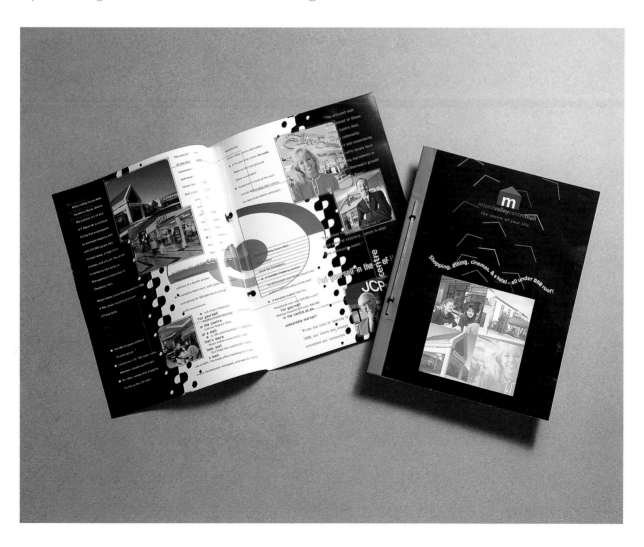

16

DIRECT MAIL

If you have a mailbox, then you've received direct mail. Companies send direct mail with the expectation that they'll get some type of response to an offer. It's the one part of a marketing program for a product or service that can generate a measurable response to a specific offer. "Very few other sales methods can do that," says direct mail and communications consultant Sandra Blum. "Plus direct mail is generally not as costly as telemarketing or one-on-one selling, for example."

The success of a direct-mail campaign lies primarily in the quality of the list to whom it is directed. "It's generally accepted that a high-quality list with recent names and accurate addresses accounts for 60 percent of the success of a direct-mail piece," says Blum, who codeveloped a CD-ROM entitled *Mail Marketer—Grow Your Business Using the Mail.* "The offer accounts for 20 to 30 percent, and the design 10 to 20 percent."

But don't think that means design plays an insignificant role in motivating people to act on the offer in a direct-mail piece. "A good design can really drive the direct-mail process," Blum says. "If you don't understand the classic rules of direct-mail design—for example, if you've hidden the offer and made the recipient work too hard to find it—you've screwed up your 10 to 20 percent of the potential success of the package." Plus, you've had a negative effect on the 20 to 30 percent interest generated by the actual offer.

POINTERS FOR GOOD DIRECT-MAIL DESIGN

Blum says there are a few tried-and-true rules governing direct-mail design:

• Make sure the offer catches the recipient's eye immediately. The whole piece should be designed to encourage the person to act on impulse.

• Use spot color to support reading.

• Use "sight bites" of copy. Small, digestible chunks are most effective.

• Make sure the response device—whether it's a toll-free number to call or a business reply card—stands out.

• Colored envelopes can help get the recipient's attention.

• The type has to be readable. "People only skim direct mail." If the offer doesn't hit them in the face when they first open the piece, then you've probably lost them. That's why you see so much underlining, ellipses, subheads and so on, in direct-mail pieces. "The circus-like feel of a lot of direct-mail pieces is intentional," Blum says.

Of equal importance, Blum says, is to look at direct-mail pieces that work. Denison Hatch's book *Million Dollar Mailings*, for example, features a number of successful direct-mail campaigns and includes a list of different types of mailings, with numbers you can call to get more information.

And ask a lot of questions about the list of people who will be receiving the piece, Blum stresses. "Examine its 'recency frequency monetary,' or RFM," she says. Look at how recently the names came onto the list, how frequently during a specified period those people responded to a mailing and how much they spent on the transaction that transpired from the mailing. Also look at the results of past mailings to the list and what offers people responded to.

It all comes down to targeting the market and understanding its needs, Blum says. "Try to develop a profile of the market and then design what appeals to those people."

Masi Graphica Helps Design Academy Recruit Students

PROFILE: MASI GRAPHICA LTD., CHICAGO, IL

FOUNDED: 1989, by Eric Masi and Kevin Masi

EMPLOYEES: Four designers

SERVICES: Graphic communications and design

MAJOR CLIENTS: Sears, Ameritech, American Express, Prime Retail, Anheuser-Busch, Budget Rent-A-Car

FORMAL MARKETING EDUCATION: None

For Chicago-based Masi Graphica Ltd., the challenge in designing direct mail is getting the client to realize that the piece will have little impact if they haven't pinned down who their audience is and what actually appeals to them.

"The majority of businesses coming to a studio of our size are mid- and small-size companies," says creative director and designer Eric Masi. "They don't want to spend a lot of money on marketing. They'll take a shotgun approach to their direct-mail pieces. For the designer, that means we have to give the piece a universal appeal. That's rarely effective."

EDUCATING THE CLIENT

Masi says he tries to convince clients that it's much more cost effective to spend the time and money assessing the target market and determining how best to communicate with them via direct mail. "As a designer, you have to ask a lot of questions, assess the information needs of those who are to receive the direct-mail piece," Masi says. "You can't just design your vision with no outside constraints."

For the International Academy of Merchandising and Design (IAD), a fashion and design college in Chicago, Masi developed a direct-mail piece that

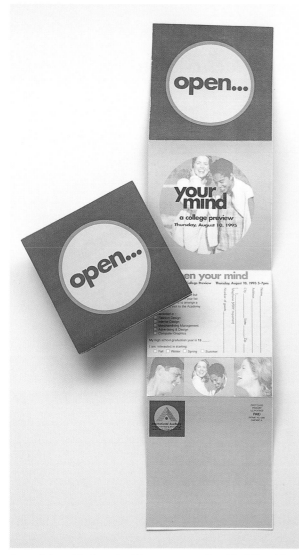

One of three black-and-white comps used by Masi Graphica in a second round of focus group testing, this piece uses a simple accordion fold and photos of young people smiling and laughing.

direct-mail pieces a year and running ads in local papers in the spring and fall.

"They weren't worried about their numbers slipping, but they were eager to upgrade their image while interest was high," Masi explains. "We convinced them that the design of their pieces needed to change in order for them to convey this, but we also stressed that it wouldn't work unless we all understood better who our market was and what they responded to."

GETTING STUDENT INPUT ON DIRECT-MAIL SOLICITATIONS

As part of its recruiting program, the school holds open houses twice a year for prospective students. Masi Graphica was charged with designing the announcement for the event that would be sent to the academy's existing mailing list.

Using comprehensive demographic information on students gathered by the academy, Masi developed a general student profile. "We knew that based on the data, we were dealing with a younger crowd looking for an alternative higher education experience."

Masi hooked up with a Chicago marketing consultant to do focus group testing to research what appealed most to students in direct-mail solicitations from schools.

They held two rounds of testing. In the first round, they had three groups consisting of twelve to twenty first-year college students who volunteered to participate in the testing. They used new students since they were the ones who were most likely to remember the recruiting information they had received.

Students were shown a dozen or so samples of direct-mail pieces from other schools and were questioned on their design, content, format and general message. They were also asked whether they would have opened the piece, read it and responded to it. Masi worked closely with the marketing consultant to develop the focus group questioning. Although the client reviewed the questions, Masi says, "they looked to us mostly for guidance."

Students tended to respond to the more elaborate and contemporary-looking pieces presented, Masi

effectively marketed the school to prospective students, but didn't cost a bundle.

IAD offers two- and four-year degrees in fashion design, interior design, merchandising management, advertising and design, and computer graphics. It has about 2,500 students at its Chicago campus. It also has a satellite campus in Florida.

Although in recent years IAD had been experiencing a steady increase in enrollment, primarily because of its strong computer graphics program, it didn't have a structured plan in place to market itself as a cutting-edge design school. For the most part, its recruiting effort consisted of sending out two or three

explains. They liked playful but sophisticated presentations. They also favored lots of color, although not any one color in particular, and unusual formats. Being able to interact with the piece was also important. They liked graphic illustrations as opposed to photos. For content, students said they were not likely to read a lot of material. A few key words that applied to them made the biggest impression.

DEVELOPING DESIGN COMPS BASED ON CONSUMER FEEDBACK

Using these responses, Masi developed three sets of black-and-white design comps to present in the second round of focus group testing. One was accordion-folded and opened vertically; one opened horizontally, panel by panel; and the other was a square-shaped piece with two flaps that folded together like a barn door. Two pieces used illustrations while the third relied on stock photos. Students were asked to comment on the format, the amount of information and its usefulness, and whether they preferred photographs or illustrations.

Students responded most favorably to the square format with the more unusual barn-door flaps. They also liked illustrations (as opposed to photos) and responded to key words in the text.

CREATING THE FINAL PIECE

Masi modified the chosen piece to be a self-mailer. The final piece (when folded) measures roughly 6" x 6". Three triangular-shaped flaps fold over a square business reply card that serves as the fourth flap and has the word "Open" on its exterior side. The word not only serves as instruction but also introduces the theme of the open house, which is "Open Your Mind." The IAD logo is triangular in shape, so the triangular flaps help reinforce recognition.

The outside of the piece uses various shades of purple while the top triangular flap has an illustration of a book and diploma on it. When the piece is opened, the student sees a striking black background with a

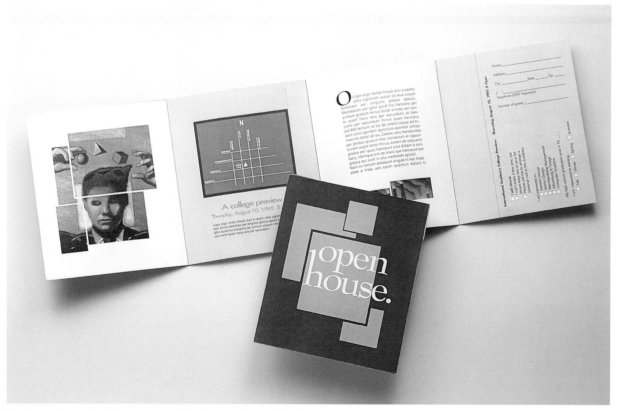

Another black-and-white comp used in the second round of focus group testing uses stylized illustrations rather than photos. This piece also has a relatively simple fold, opening to reveal one additional panel at a time.

prominent illustration depicting the various areas of study the college offers. There's a male and female student amidst a computer monitor, scissors, buttons, a drafting board and a fashion dummy. The book and diploma illustration is repeated on the inside.

Copy on the inside of the three triangular flaps is also set against the black background. It announces the date and time of the open house, provides a map and summarizes the academy's offerings. The fourth (square) flap lists the activities planned for the open house and includes a perforated business reply card.

MEASURING THE RESULTS

About 5,000 announcements were printed and sent to students in the region in two mailings. According to Masi, the academy saw a 20 percent increase in attendance to the open house over the previous two open houses held. The business reply card included in the mailer also generated a lot of response.

Masi estimates that he spent ten to twelve hours on the marketing research phase of the project and he charges $85/hour for this type of consultation.

"In the long run, it's much more effective if you can convince the client that they should assess their target market and understand the audience that's going to be interacting with the direct-mail piece," he explains. "If they spend more money on that phase of the direct-mail project, they'll be more effective in communicating and will probably be spending their money more efficiently."

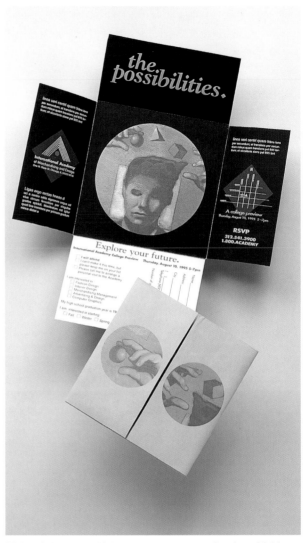

This third comp, which uses a more unusual series of folds, snippets of copy and stylized illustrations, was the most popular with students in the second round focus group. This comp was used as the basis for the final design.

PROJECT CREDITS
ART DIRECTION: Eric Masi
DESIGN: Eric Masi, Josephine Chen
ILLUSTRATION: Eric Masi

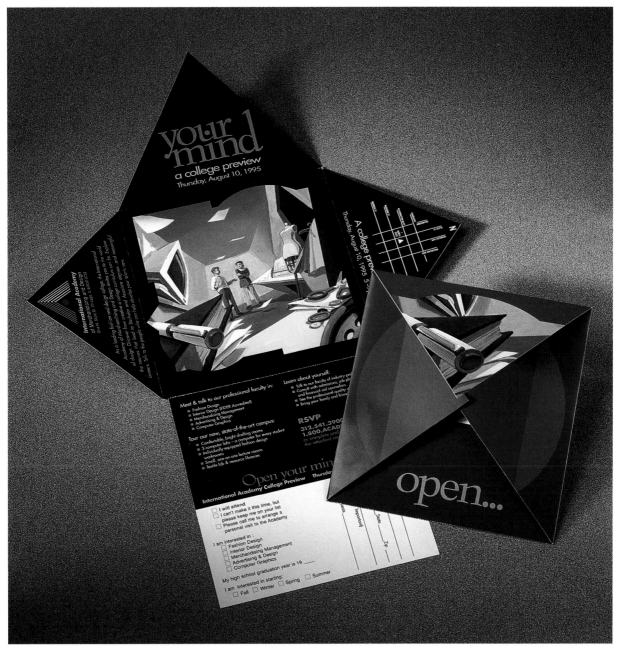

Masi modified the final piece so that it has three triangular-shaped flaps folding over a square business reply. Illustrations, striking colors and short blurbs of copy immediately communicate the offer.

DIRECT-MAIL PROJECTS

BROCHURE FOR PAPER CHASE PRINTING

DESIGN STUDIO: Hal Apple Design, Inc., Manhattan Beach, CA
ART DIRECTION: Hal Apple
DESIGN: Karen Walker, Sepi Banibashar
COPYWRITING: Karen Walker
ILLUSTRATION: Various
PHOTOGRAPHY: Hector Prida, Jason Ware, Saul Lieberman, Delbert Garcia, Muybridge

This direct-mail piece designed by Hal Apple Design, Inc., was only a small part of a complete marketing plan the designer developed for Paper Chase Printing.

In an effort to grow its printing and prepress work, Paper Chase had determined that it should target designers and ad agencies for new work. Hal Apple Design devised a plan to get this new work that included a suggested direct-mail strategy, advertising suggestions and the recommendation to hire a full-time sales representative.

Apple developed the strategy based on results of his own creative research. He first enlisted the freelance services of a printing sales representative who had formerly sold work for a small, high-end printer comparable to Paper Chase, but who had since moved to a position with a large, noncompeting printer. The sales rep, Apple and the project designer sent out a bid request for a typical job (a real job that needed printing) to ten printers in order to evaluate their pricing structures and services. A handful of designers were also informally surveyed on their reasons for picking particular printers. Competitors' ads and direct-mail pieces were gathered and analyzed. And Paper Chase's existing telemarketing efforts were reviewed and critiqued by the printing sales rep.

From the research, Apple formulated a list of the top ten concerns of Paper Chase's potential customers. This list served as the basis for the new marketing plan, including the direct-mail piece shown here, which consists of perforated pages that can be torn out and used as postcards. The theme of the piece is the ten primary reasons why designers should choose to use Paper Chase printing.

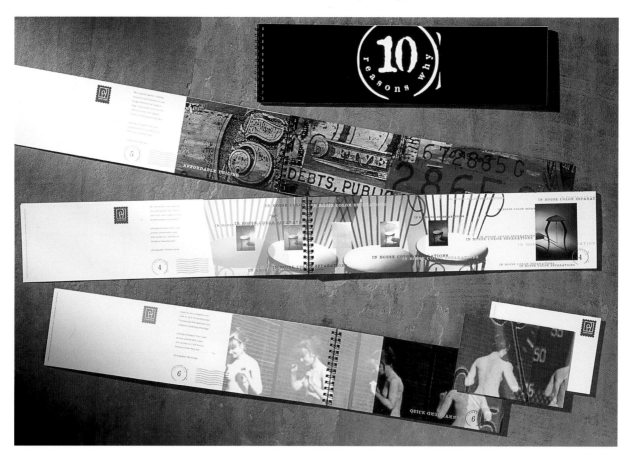

NEWSLETTER FOR THE IAMS COMPANY

DESIGN STUDIO: Wilz Design, Inc., Cincinnati, OH
ART DIRECTION: Wilz Design, Inc.
DESIGN: Melissa C. Wilz
COPYWRITING: The Marketing Shop

This newsletter is a key part of Dayton, Ohio-based The Iams Company's "relationship marketing" program with important, influential and knowledgeable consumer groups. The newsletter is distributed four times a year to cat breeders, a group most likely to feed their cats Iams cat food. The objective is to open dialogue between breeders and The Iams Company, communicate Iams news and reinforce The Iams Company's position as the leader in the industry. In addition, a coupon for Iams cat food products appears in the newsletter as a way to generate and measure consumer response and interest.

Designer Melissa C. Wilz uses a variety of marketing research tools to develop the design of the newsletter. Surveys and one-on-one interviews with a random sampling of cat breeders around the country, informal discussion groups at cat shows and cat club meetings, and input from the Cat Breeder Advisory Board, which consists of top breeders from around the world, help Wilz determine the type of information, photos and graphics to be included in each issue and in what order.

Of particular importance, she says, is establishing a strong connection between readers and The Iams Company through use of well-known Iams graphics. Results of the newsletter program have been very positive. Wilz says Iams' Breeder Specialty Programs phone line has experienced increased calls.

NEWSLETTER FOR IBBOTSON ASSOCIATES

DESIGN STUDIO: Masi Graphica Ltd., Chicago, IL
ART DIRECTION: Kevin Masi
DESIGN: Josephine Chen
COPYWRITING: Derrick Wilkinson, Kristin Lechner

To increase awareness of Chicago-based Ibbotson Associates' capabilities and services as well as increase brand equity and recognition, Masi Graphica designed this newsletter that highlights Ibbotson's Institutional Software + Data Group. The newsletter is sent quarterly to money managers, consultants and financial managers at corporations.

The Masi design team evaluated competitors' newsletters to learn from successes and failures, and also to come up with a look that set Ibbotson apart. Clients were surveyed to find out what topics they would find informative and relevant in a newsletter and in what tone or manner they would like the information presented.

Based on this research, the designer could eliminate approaches already taken by competitors. The team also knew that readers wanted a newsletter that was easy to understand. For the final design, the design team applied certain corporate graphic standards that Ibbotson had developed for all its communication materials, but also incorporated vibrant colors, playful graphics and a nontraditional format that makes the piece more entertaining and reader-friendly. Ibbotson phone numbers and e-mail addresses are included on various articles for customers to call for more information on a new product or service.

Masi says that response to the newsletter has been very positive, and it has generated a considerable number of inquiries since its inception.

SELF-PROMOTIONAL NEWSLETTER FOR SCOTT HULL ASSOCIATES

ART DIRECTION: Ken Botts, Tracy Meiners
DESIGN: Visual Marketing Associates
ILLUSTRATION: Various

Dayton, Ohio-based Scott Hull Associates is in the business of marketing the work of illustrators, so Hull knows the importance of understanding marketing principles when it comes to marketing his own business.

This newsletter is distributed to about 3,000 buyers of illustration three times a year. It is not only intended to keep the art buyer aware of what's happening with the artists represented by Scott Hull Associates, but also to inform them of trends and issues affecting the visual communications industry.

In developing the content and design, Hull surveyed art buyers and potential readers via phone and in-person at industry conferences to find out what type of information they'd like to read and what issues are affecting their industry. The design, he determined, should appeal to the high-end art buying community.

The final product is a crafty combination of artists' illustrations placed throughout the eight-page publication and articles that are informative and have a how-to slant to them. Hull also enlisted the editorial support of a well-known writer and editor in the industry to give the newsletter more credibility.

Hull says the newsletter as a marketing tool serves as the company's professional voice to the arts community. "It's helping build awareness of the creative talent we represent."

ADVERTISING

Advertising is generally defined as communication through mass media channels, such as television, radio, print, outdoors, mail and now, the World Wide Web. In the marketing mix, advertising is a promotion tool whose purpose is to edge the target audience (the customer) one step closer to purchasing a product or service.

Successful advertisers rely heavily on research to plan and prepare an advertising campaign. Studying the customer—the end user—and evaluating buying habits is crucial, as is a thorough analysis of the advertising medium's audience. Government and commercial data sources provide huge amounts of information on consumers and most publications and other advertising media have detailed audience profiles available.

Historically, advertisers have turned to advertising agencies to conduct the necessary research. But, more and more frequently, the creative team who's called in to design and produce the advertisement is now expected to understand and often define the audience that will receive the advertiser's message, and then to determine the most effective way to deliver that message.

THE DESIGN STUDIO AS AD AGENCY

Says Saïd Osio of Miami, Florida-based marketing and communications design studio Pinkhaus, "Clients used to go to an ad agency to develop the campaign, and then to a designer to design the ads. Now, they're creating integrated marketing teams that designers are a part of. We might be working with an ad agency or doing the campaign on our own. Regardless, the designer still has to understand the client's goals, target audience and what they expect the advertisement to accomplish."

Indeed, planning an advertising campaign requires research into the characteristics or features of a product or service that differentiate it in the market; evaluation of the form of advertising that's the most effective in communicating the message; and development of a method or device for measuring results. On top of all that falls the task of being creative.

As Thomas O'Guinn, Chris Allen and Richard Semenik write in their book *Advertising*, ". . . creativity is what separates the highly effective message from the mediocre message." The message is simply what is said or shown in an ad, through copy and/or art. The goal of any message, the authors write, is to attract attention and create a positive, memorable impression of the product or service.

For the creator of the message then (which could likely be a graphic designer or design firm), the authors recommend developing a message strategy that defines the goals of the advertisement and the methods used to meet those goals. For example, if you're trying to differentiate a product or service from the competition, you might use humor or sexual appeal ads. If you're trying to create awareness, repetition of ads might be the best method for meeting the goal.

"Great messages are developed by people who can put themselves into the minds of their readers and anticipate the response, leading to the desired outcomes." Message development, they contend, is where the advertising battle is usually won or lost.

Pinkhaus Develops Ad Campaign for Jamaican Resort

PROFILE: PINKHAUS DESIGN CORP., MIAMI, FL

FOUNDED: 1985, by Joel Fuller

OFFICES: Based in Miami but merged with The Designory, Inc.

in Long Beach, California, in May 1995

EMPLOYEES: Fourteen, including seven designers

SERVICES: Marketing and communications design, marketing consulting

MAJOR CLIENTS: Royal Caribbean Cruise Line, Motorola Paging, Bacardi,

Mercedes-Benz of America

The lush scenery and romantic appeal of Jamaica make it one of the hottest destinations for North American tourists. Posh resorts speckle its beaches and lure tourists with visions of umbrella drinks, tropical delicacies and peaceful afternoons under clear blue skies touched by the gentlest ocean breezes.

Swept Away Resort, located in Negril, Jamaica, was marketing itself that way, too, until its owners decided it was time to break away from the pack.

Swept Away was founded and is owned by third-generation Jamaicans who spared no expense or effort in creating a facility that provides a truly authentic Jamaican experience. Jamaican authenticity and hospitality are apparent throughout the 130-suite facility, from the materials used in the building (which are indigenous to the area) to the artwork done by local artists.

"We truly are different from the other resorts in Jamaica," says Joy P. Norwood, director of sales and marketing. "Although pricing and services are similar to our competitors, who have 1,800 and 2,200 rooms, we offer a quality of experience that's different from the rest, and cater almost exclusively to couples."

But Swept Away's uniqueness was lost in its advertising and sales materials. "Our stuff looked like every other hotel's materials so . . . we were positioned in the market to be like every other hotel," Norwood says. "Because we don't have a sales force or the opportunity to do as much promotion as our competitors, our ads and collateral are so important in telling our story. We wanted to pull away from the pack and our communication materials are the key to helping us do that."

The resort approached Miami, Florida-based Pinkhaus Design to create ads and sales materials that more accurately reflected its unique essence, and to position it as a one-of-a-kind destination in the minds of both consumers and travel agents.

PINKHAUS GETS SWEPT AWAY

What Pinkhaus saw in Swept Away was a "pearl that needed to be uncovered."

"The first thing we noticed about the resort is the richness in detail," says Pinkhaus's Saïd Osio. "The construction, textures and colors all come together so skillfully to form this whole tapestry of images. You find yourself 'experiencing' the landscaping, or experiencing a piece of ironwork. It's almost like an Impressionist painting."

Osio and other members of the design team, including Pinkhaus founder and creative director Joel Fuller, spent several days in Jamaica auditing competing resorts and developing an image of Swept Away.

What they found was that most resorts had positioned themselves to appeal to the mass market vacationer, and their ads and sales materials reflected this. It's almost without exception that they include a beach shot, fitness shot and food shot, Osio says. Swept Away, on the other hand, tended to attract couples who were in Jamaica to experience the romance and culture.

"We knew we wanted to get away from the 'clichés' that characterize the information and collateral sent out by other properties," Osio says. "And we knew we wanted to target a special type of vacationer and a special type of travel agent who would sift through the clutter to find this special destination."

Osio, Fuller, copywriter Frank Cunningham and art director Todd Houser developed a list of impressions of Swept Away based on interviews with its owners and staff, observations of the resort's clientele and perceptions they had as guests of the resort. What impressed them was the authenticity of the resort, its richness and romance, and the experiences it offered. "It became pretty obvious that what we needed to sell was the experience, not the things," Osio says.

TRANSLATING IMPRESSIONS INTO ADVERTISING IMAGES

They produced a set of "mood boards" that represented their impressions. For the boards, the team assembled scrap photos that they felt conveyed the emotions and impressions they experienced at Swept Away.

These impressions then became the basis for an on-site photo shoot with photographer Michael Dakota. Photos dominate the centerpiece of the campaign—an eight-page, full-color brochure. A sunset photo placed on a fan-shaped leaf on the front fold-out cover immediately conveys the tropical experience you can expect at Swept Away. The rich green and orange colors set on an ivory-colored background exude quality and beauty. A peacefulness and serenity are reflected in the purposefully blurred inside front cover photo of luscious foliage set against rolling clouds in a vibrant blue sky.

Throughout the remaining spreads, you see photos of young, beautiful couples experiencing the resort's services—a man playing tennis with the shadow of his female partner holding a tennis racket subtly captured in the photo; a long-legged woman in a sleek, black bathing suit carrying scuba gear toward a man barely discernible in the background of the photo. The back cover folds out to reveal a two-page photo of a couple on the bed in one of the Swept Away suites, gazing out onto a veranda that overlooks a palm-tree shaded beach. Other photos of tropical flowers, fresh vegetables and fruits, and music are placed throughout the brochure to appeal to the senses.

An elegant script font, which almost "moves" as you would expect to see leaves blowing in the wind or waves washing ashore, helps lead you from page to page. Only small blocks of copy that highlight the experiences are included.

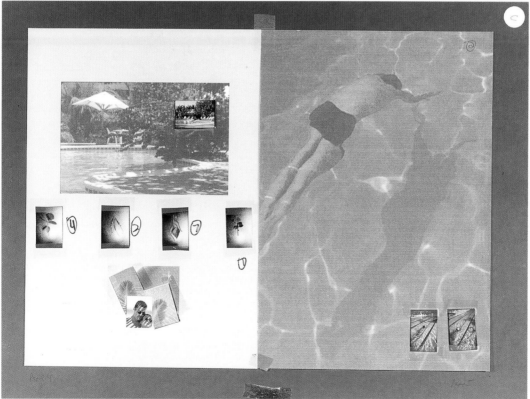

During a visit to Swept Away, the Pinkhaus design team developed a set of impressions and emotions evoked by the resort. Stock and scrap photos representing these impressions were assembled on a set of eleven mood boards, two of which are shown here. These boards then became the basis for the on-site photo shoot. Prints from the photo shoot were inset on corresponding photos on the mood boards.

CREATING THE SUPPLEMENTARY PIECES

The brochure was distributed to both travel agents and consumers. In addition, quarter and half-page ads were created using some of the same photos in the brochure and placed in trade and consumer publications. Although the ads still convey the quality of experience that makes Swept Away so unique, Pinkhaus had to design them to address their specific audiences. The consumer ads, which appeared in bridal and general travel publications, convey a mood and zero in on the romance and the resort's attention to couples. The trade ad is designed for travel agents who want information and are less concerned with image and mood.

Two smaller brochures—one outlining rates and services and the other promoting the resort's wedding and honeymoon planning services—were also created.

Norwood says that since the new materials became available, there's been a tremendous response from travel agents and tour operators. "We figured the travel agent community would either love it or hate it," she says. "And they seem to love it."

Swept Away's honeymoon and wedding business has increased and the new campaign has helped strengthen the resort's repeat customer base. "We're also seeing very minimal seasonal shifts in bookings," Norwood says. "During the off-season, our bookings are at 80 to 90 percent, which is far above the average in the industry."

Norwood adds that the new materials successfully capture the casual elegance and quality of Swept Away. "They've really given us a more accurate positioning in the market."

PROJECT CREDITS

CREATIVE DIRECTION: Joel Fuller
ART DIRECTION: Todd Houser
COPYWRITING: Frank Cunningham
PHOTOGRAPHY: Michael Dakota

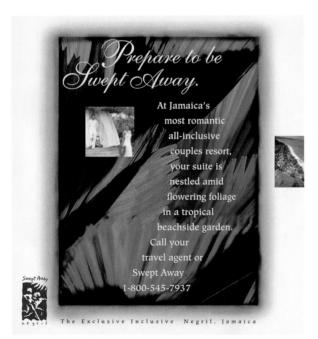

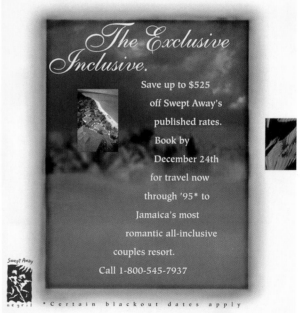

To promote the resort as an ideal venue for a wedding and/or honeymoon, Pinkhaus designed this consumer ad to appear in bridal magazines. The lush green foliage and seductive photo of a young couple in white entices lovers to experience the romance. While images and impressions still play a vital role in the trade ad, Pinkhaus focused more on motivating travel agents to act by giving them information on Swept Away's prices and services.

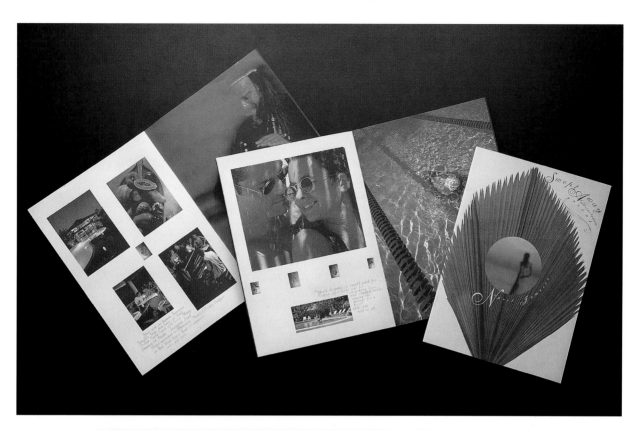

▲ Photos dominate the eight-page, full-color brochure. Young, beautiful couples experiencing Swept Away's beauty, romance and serenity are featured throughout. Photos of tropical flowers, fresh vegetables and fruits and music help complete the sensual presentation. As you can see, the final brochure doesn't differ much from the mood boards created by the design team.

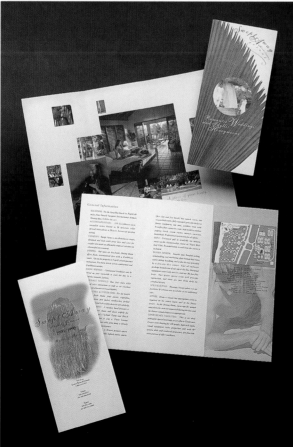

To supplement the main brochure, these two smaller brochures were created. One outlines rates and services; the other promotes the resort's wedding and honeymoon planning services.

ADVERTISING PROJECTS

MAKITA USA

DESIGN STUDIO: Mike Salisbury Communications Inc.,
 Torrance, CA
ART DIRECTION: Mike Salisbury
DESIGN: Mary Evelyn McGough
BEAR DESIGN AND ILLUSTRATION: Doyle Harrison
PHOTOGRAPHY: Henry O. Blackman

When Makita USA Inc. started losing share in the power tool and construction market to newcomer DeWalt, they turned to Mike Salisbury Communications to develop a marketing program that would reassert their presence in the trade market and establish the company as a major player in the do-it-yourself market.

"Makita had traditionally sold only to tradespeople," Salisbury says. "When they came to us, they were in a quandary over losing market share and how to expand their offering to the consumer market."

To develop a targeted campaign, Salisbury visited mass market retail outlets and home improvement centers where he observed how power tools were merchandised and sold. He interviewed users of the tools and utilized research gathered by an associate on the do-it-yourself market.

From the market research, Salisbury determined that Makita needed to position itself in a way that appealed to both the hard-core construction/building market and to the less-experienced consumer market. The design team decided on an advertising and promotional campaign that uses a bear to represent the tough, masculine nature of Makita products but which can also be interpreted as warm and friendly by the less-experienced user. Makita's trademark bright blue color is used in all communication and marketing materials, including print and television advertisements and the stuffed bear and coffee mug tradeshow giveaways.

The blue color and the bear are synonymous with quality, Salisbury says, and have created greater brand recognition in the consumer market.

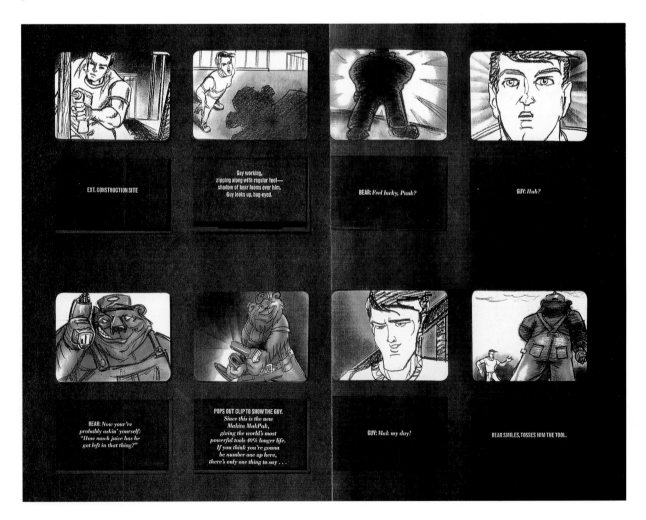

Longer and faster than ever before.

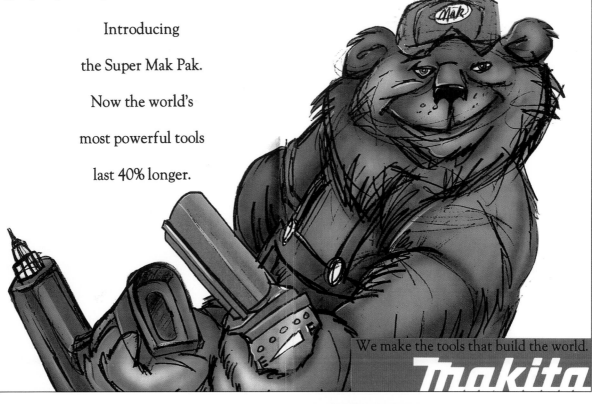

Introducing

the Super Mak Pak.

Now the world's

most powerful tools

last 40% longer.

We make the tools that build the world.

makita

GE CAPITAL

DESIGN STUDIO: After Hours Creative, Phoenix, AZ
PHOTOGRAPHY: Art Holeman

This national trade advertising campaign targeted at corporate purchasing managers, financial officers and managers, and travel managers, has helped generate qualified inquiries about two new GE Capital products.

Before developing the campaign, After Hours Creative reviewed extensive existing research to understand the overall image, character and perceptions of the GE and GE Capital brands. In addition, the design firm worked in partnership with the client to conduct two focus groups consisting of representatives from the target market to learn about their perceptions, desires, suggestions and more. Phone interviews with the client's sales staff and support personnel further helped the design team understand GE Capital's internal operations, opinions and sales methods.

Russ Haan of After Hours says the research, which he estimates cost about $20,000, gave the design team a much clearer understanding of how customers viewed the client and its offerings versus how the client viewed the same offerings. "The results helped us unite the design of advertising and sales collateral with the customers' desires," Haan says. The final product is a series of full-page, full-color ads that are engaging and fun. "Our design was 'less stuffy' and better matched the desires of the marketplace," he explains. "The research really helped us better understand the sales process so materials are more appropriate to the part of the sales process in which they will be used."

NEWSPAPER ADS FOR CHICAGO ANTI-CRUELTY SOCIETY

DESIGN STUDIO: Masi Graphica Ltd., Chicago, IL
ART DIRECTION: Eric Masi
DESIGN: Eric Masi, Josephine Chen
COPYWRITING: Eric Masi

This newspaper advertising campaign for the Chicago Anti-Cruelty Society represented the first time the organization had targeted its ads to an identified clientele. With the assistance of Masi Graphica, the society collected data from pet adoption surveys that found that pets are adopted most often by young, single, urban residents.

Research and understanding of the marketplace inspired Masi to develop these contemporary black-and-white ads that focus on the idea of companionship.

The ads ran in local newspapers and, according to Masi, there has been an increase in pet adoptions as well as positive feedback on the campaign in general.

WEBSITE FOR ARC ABRASIVES, INC.

DESIGN STUDIO: 1•earth GRAPHICS, Troy, OH
ART DIRECTION: Jay Harris
DESIGN: Lisa Harris
ILLUSTRATION: Lisa Harris
COPYWRITING: Mark Palmer
PHOTOGRAPHY: AGI Photographic Imaging

Arc Abrasives is a Troy, Ohio-based company specializing in abrasives for woodworking, metal finishing and other industrial applications. Customers include product distributors and manufacturers who buy directly from Arc. Working with 1•earth GRAPHICS, Arc developed an online advertising and promotional campaign that extends the company's sales and marketing channels to more distributors and directly to customers.

Before designing a website, 1•earth identified key competitors and researched their online marketing programs. "What we found," explains Jay Harris of 1•earth, "is that they were not targeting end-users as we were planning to do for Arc." Harris also researched various online services before settling on Industry.Net, which has 4,500 business centers in related fields and has posted more than 180,000 hits by qualified buyers.

In designing the site, 1•earth paid close attention to the special needs of Arc's two distinct markets: the current distributors who are already knowledgeable about the products, and the end users, who need a simple introduction to the products. 1•earth applied design

features already developed for Arc corporate identity materials to the website design. A simple introduction to abrasives is followed by information on Arc products and services and complemented with practical, eye-catching graphics. The website address is listed on the company's general brochure and was advertised via a direct-mail campaign.

Harris says the site generated close to ninety qualified sales leads in its first quarter of existence.

PUBLIC RELATIONS AND CONSUMER EDUCATION

Public relations and consumer education programs can be powerful tools in building positive relationships with existing and potential customers, employees, stockholders and the public in general. At the core of any such program is the desire to develop further a company's relationship with its constituent groups so that it will result in an equally positive effect on the bottom line.

Many companies sponsor an event, like a tennis championship or the Olympics. Or, they align their name with a charitable or not-for-profit organization, like little league baseball or a performing arts group. Or, they might sponsor a free seminar or simply send out press releases announcing awards, promotions and achievements.

Regardless of the tool or technique, the goals are the same: to generate positive interest and enthusiasm toward the company, which will lead to greater awareness in the marketplace, increased loyalty among consumers and stronger numbers on the balance sheet.

With that in mind, designers of public relations and consumer education materials must have a clear understanding of a company's existing relationship with its publics and what it hopes to achieve or how it hopes to affect those relationships with a particular campaign. Is an effort designed to bring in new business or strengthen current operations? Is it meant to upgrade or enhance the current image? Is it to establish an image or awareness where none exists? Or, is it to provide the consumer with information that will help them make decisions?

SUCCESSFUL PUBLIC RELATIONS

In his book *The Master Marketer*, Christopher Ryan lists four rules for companies to follow in establishing and maintaining strong relationships with their publics:

1. Determine what they want by asking or surveying them.

2. Be diligent in collecting information on your constituent groups, including customers, stockholders, suppliers, employees, government entities, educators, citizen action groups, the local community and the general public. And keep the information up to date.

3. Provide incentives that bring your publics closer to you and build loyalty.

4. Offer recognition of your constituent groups. It shows you care.

After Hours Creative Helps Educate Teenagers

PROFILE: AFTER HOURS CREATIVE, PHOENIX, AZ

ADDITIONAL OFFICES: Atlanta, GA

FOUNDED: 1989, by Russ Haan

SERVICES: Corporate identity, branding, new product/business launches, advertising and all other aspects of graphic design

EMPLOYEES: Eight—four designers, one production support person, one writer and two administrative people

MAJOR CLIENTS: IBM, Coca-Cola, GE Capital, The Southern Company, Honeywell

FORMAL MARKETING TRAINING: None, but Haan's background is in genetic engineering, which requires a lot of research savvy and skill.

APIPA, the Arizona Physicians Independent Professional Association, is a health maintenance organization based in Phoenix, Arizona, which has about 10,000 births on its plan every year. Of those, roughly a third are to girls under the age of eighteen. Statistics show that young women who get pregnant at this age have a significantly greater chance of delivering low-weight babies and experiencing complications during their pregnancies. Furthermore, low-weight children often experience more health problems than heavier babies. This all translates into higher health care costs for everyone.

To stem the number of premature births and reduce the risk of complications during pregnancy, APIPA embarked on an aggressive health promotion and education project that cost about $250,000 but netted the organization millions of dollars in savings in health care costs.

They enlisted the aid of After Hours Creative, a

▲ At the beginning of the project, the only design criteria APIPA had established was that they wanted some type of box that would contain information on contraception and prenatal care. Based just on that, After Hours developed some initial renderings of how the kit might look.

Phoenix-based design firm that was referred to APIPA by a local printer.

After Hours' task was to develop a kit for use by APIPA social workers to educate young women on how to deliver healthier babies and prevent or delay a second birth. Creative director and designer Russ Haan says that during all phases of the project, the designers were looked upon as a consultant as well as a design firm.

TURNING RAW DATA INTO MARKETING INFORMATION

At the start of the project, Haan says the client didn't have a good grasp of how best to communicate with their target market. They had a lot of detailed data from caseworker files that characterized the personalities of the young women, their income levels, education, race and health histories; however, they really had no proven methods for communicating with or educating them on the health risks and costs of teenage pregnancies and poor prenatal care.

"We knew who our audience was and we knew what we wanted to accomplish," says Dr. Don Umlah, director of Prevention & Wellness Programs and Quality Management at APIPA. "But we hadn't really thought about how to deliver the message. They (After

▲ Three general design directions were tested. One used brightly colored type, one used solid panels of bright colors and the third used photographic images of young moms and kids.

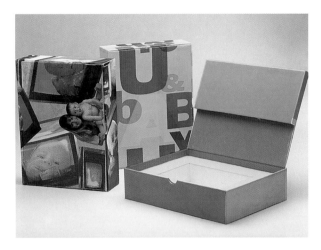

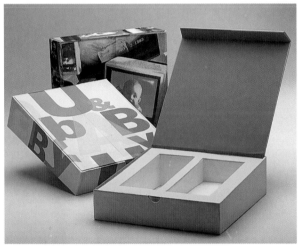

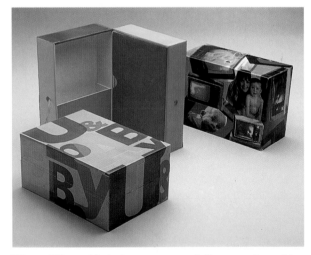

Three different kit designs were tested. One was a box with a single large compartment and a folder attached to the inside of the lid; another was a desk-type box with two compartments; and the third opened like a book to display a slot (for brochures and pamphlets) plus had an enclosed compartment. Each of the three designs was applied to each of the three box types for testing purposes.

Hours) brought marketing skills and tools to the table as well as some very creative ideas."

The only design criteria APIPA had established was that they wanted some type of box that would contain information on contraception and prenatal care. Based just on that, After Hours developed some initial renderings of how the kit might look.

GETTING TO KNOW THE MARKET

"Our all-male design team had lots of ideas about what we should show in the communications materials, how it should be presented, etc.," Haan says. "Then it sort of dawned on us in the middle of a creative meeting that it was totally inappropriate that we do this project without talking to the target audience." In addition, because the implementation costs of the project were so high, it was vital that the materials be effective and usable by the young women who were targeted.

After Hours and APIPA decided to conduct focus groups of the girls who would be receiving the information. They developed a set of questions and worked with an independent research firm to conduct the testing. Two groups of young women were interviewed, both groups comprised of eight to ten participants. Haan and the After Hours team created nine different kits on which they tested design formats, content, writing styles and the overall presentation. Three general design directions were tested. One used brightly colored type, one used solid panels of bright colors and the third used photographic images of young moms and kids.

Three different box configurations were also created. One was a box with a single large compartment and a folder attached to the inside of the lid; another was a desk-type box with two compartments; and the third opened like a book to display a slot (for brochures and pamphlets) and an enclosed compartment. Each of the three designs was applied to each of the three box types.

Focus group participants were also asked how copy should be presented. Brochures, pamphlets and card inserts were developed. After Hours used bulleted snippets of information on some and longer paragraph-style exposition on others.

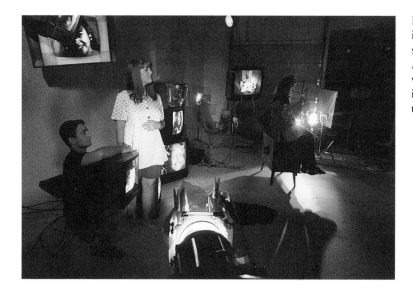

Focus groups revealed that positive, realistic images were preferable to using pure color or showing models in the photos. Based on this, After Hours chose to use photos of young women who were APIPA clients, often including their boyfriends and in some cases, their children.

The testing took about two weeks. Haan estimates that the team spent between $15,000 and $20,000 on this preliminary research and consultative work (including the research firm fees). And, it paid off.

FOCUS GROUP RESULTS

"We certainly found out that a bunch of guys can be pretty clueless about the needs of women," Haan says. "We learned that designs incorporating lots of positive, realistic images were far more preferable than pure color or ideas using models. The women really wanted people they could identify with, not just pretty young white girls with babies."

Participants also stressed that men should be included in the photos as well. After all, they didn't get pregnant all by themselves and many had strong emotional ties with the fathers of their children, even if they were not married.

"We also learned that the multiple brochure format we were going for originally was completely off-base," Haan explains. These women wanted information in short, simple blurbs. "And they loved color—lots of color and photos of real people with their partners and/or children."

Another key finding was that the women valued their privacy. They didn't want others (like their children or their parents, since many of these girls still lived at home) to be able to open the kit and see contraceptive information and birth control devices.

THE FINAL DESIGN

That led to the final design of the interior of the box. After Hours used the kit design that had the closed compartment. When caseworkers handed out the kits to young girls, they would place birth control materials, information and baby care products in the compartment. "This makes it very comfortable for them to open the box when others are around," Haan notes.

For the exterior design, and on individual information cards, the design team used photos of women who were APIPA clients. They included their boyfriends and in some cases, their children. The design incorporates lots of TV images in addition to the real-life photos. "We found that the girls watched lots of TV and they indicated that it was the best source of information, so the idea that the kit in some way represented TV was important."

The focus group testing also strongly influenced the content of the materials inside the kit. Haan says that originally, they were going to have a series of copy-heavy, descriptive brochures addressing all kinds of prenatal and health issues.

"This was scrapped once the women told us they simply wouldn't read them. Instead, we used very short, bulleted copy on postcard-like inserts to get the key points across to an audience with varying degrees of reading capabilities."

These cards used bright colors and were heavily laminated so they could withstand constant use or

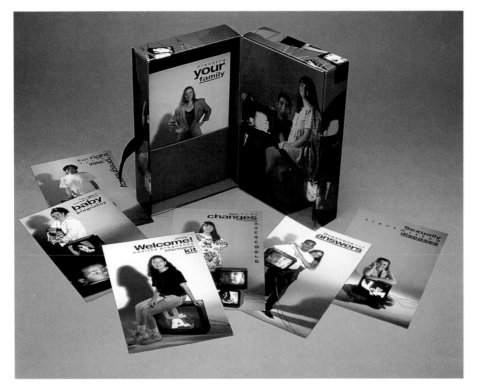

The girls' need for privacy led to the final design of the interior of the box. A closable compartment was incorporated so the girls could store contraceptive information and birth control materials. The design incorporates lots of TV images in addition to the real-life photos. Short bulleted copy on postcard-like inserts gets the key points of prenatal care across to an audience with varying degrees of reading abilities.

could be spilled on (or chewed on) without the vital information on them being damaged. Both of these characteristics are, once again, the result of the focus group testing.

THE SUCCESS STORY CONTINUES

Haan is quick to point out the value of the focus group testing and market research for this project. "Without the focus groups, we would absolutely have missed the boat on the final creative direction and set of materials produced.

"If we had not conducted it, we may have ended up with a series of brochures that never got used and a kit that did not have any pictures of men. The TV images would not have been present. We probably would have ended up with a very pretty, very 'design-ery' piece that would make male judges at design shows think we did a nice job. Without the research, we would have missed the market and possibly wasted more than $250,000 of our client's money, not to mention missing the chance to have a positive impact on some of these young women's lives."

In fact, Umlah says that one of the women featured on the box came to work for APIPA, helping to educate young girls on proper prenatal care and has since gotten off Medicaid.

The boxes have been in use for roughly two years and Umlah says low birth weight rates are down by 20 percent, which has resulted in a $2 million savings for APIPA. "The kit represents a dynamite effort," Umlah says. "We achieved what we set out to do."

PROJECT CREDITS
ART DIRECTION: After Hours Creative
DESIGN: After Hours Creative
PHOTOGRAPHY: Rick Gayle

CHAPTER 18 GALLERY

PUBLIC RELATIONS AND CONSUMER EDUCATION PROJECTS

POSTER FOR WICHITA AREA GIRL SCOUTS COUNCIL

DESIGN STUDIO: Greteman Group, Wichita, KS
ART DIRECTION: Sonia Greteman
DESIGN: Sonia Greteman, Jo Quillin
ILLUSTRATION: Sonia Greteman, Jo Quillin
COPYWRITING: Sonia Greteman

In an effort to stem declining participation in Brownies, the Wichita Area Girl Scouts Council embarked on a campaign to publicize the organization and encourage more girls to join. Greteman Group surveyed the target audience—girls aged 5 to 7—and discovered that their favorite activity is to make things. Greteman used these findings to design a poster that emphasized the many fun activities Brownies offers. The poster's message isn't just on making things, however; it's about making friends, too. The vibrantly colored poster has a three-dimensional, handcrafted look and incorporates such craft essentials as beads, fabrics, stitching and braiding. Badges, roller skates, music and campfires add to the poster's charm and allure.

The Girl Scouts Council's marketing director says the poster helped the organization achieve their desired goals. They realized a 13 percent increase in Brownie membership and reported growing enthusiasm in recruiting.

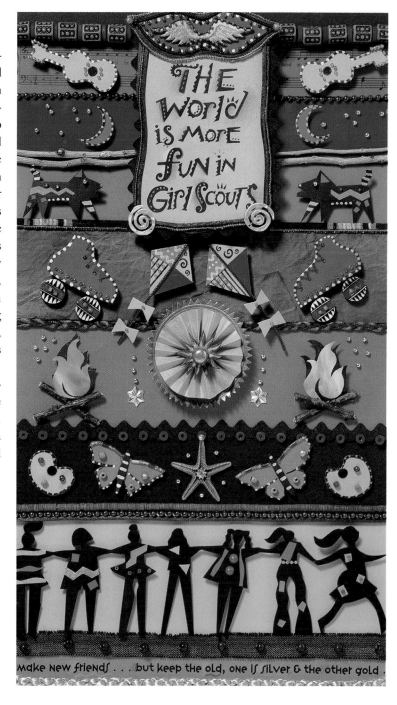

ENVIRONMENTAL GRAPHICS AND MATERIALS FOR THE LIPTON TENNIS CHAMPIONSHIPS

DESIGN STUDIO: Pinkhaus Design, Miami, FL
CREATIVE DIRECTION: Joel Fuller
ART DIRECTION: J. Norman, Mark Cantor, Claudia DeCastro, Todd Houser

A decline in interest and attendance at tennis events motivated sponsors of The Lipton Tennis Championships to rethink and reposition the tournament so it would appeal to a younger audience, yet also maintain its core audience, which consists of older fans residing near the event's Florida site.

Pinkhaus Design spearheaded a major remake of both the tournament's on-site environmental graphics and all the related promotional materials. The design team interviewed key players from Lipton and its public relations firm and led them through a series of exercises designed to clarify the desired positioning of the event. They also did an audit of the top tennis Grand Slams to determine their appeal to various segments of the market.

The redesign of the environmental graphics and signs, tickets, stationery and other promotional items features warm colors and icons (such as the sun, a tennis ball and tennis racquet) that are indicative of the Coral Gables locale. Images of current tennis stars are used in the graphics to generate energy and vibrancy. Lipton tea products and beverages are featured prominently on the backs of tickets.

The effect of the redesign on interest in the tournament has been significant, with a 10 percent increase in attendance.

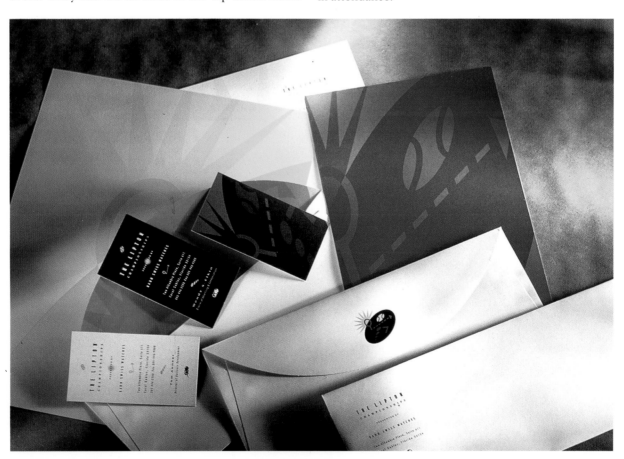

TITLE SPONSOR

THOMAS J. LIPTON COMPANY

PRESENTING SPONSOR

RADO

POSTER FOR BIG BROTHERS & SISTERS OF SEDGWICK COUNTY

DESIGN STUDIO: Greteman Group, Wichita, KS
ART DIRECTION: Sonia Greteman, James Strange
DESIGN: Sonia Greteman, James Strange
ILLUSTRATION: James Strange

Big Brothers & Sisters of Sedgwick County in Wichita, KS—the largest of more than four hundred Big Brothers agencies nationwide—relies on its annual bowling event to provide almost half of its yearly operating budget and a significant portion of the funds that go toward making new matches. In fact, the number of matches the agency is able to make is directly dependent on the success of the Bowl for Kids' Sake event. To fund current matches and increase the number of matches the agency can oversee, it is imperative that a sufficient number of people bowl in the event and/or sponsor those who do.

To generate enthusiasm for the bowling event, Greteman Group created a striking poster to appeal to both children and adults. Colors are bold and the design dramatic, especially compared to past posters that featured everything from yarn-entangled kittens to anthropomorphic bowling pins. Greteman's sophisticated, contemporary design stood out as a major departure and had special appeal to teens.

According to Big Brothers' executive director, the posters generated a remarkable number of positive comments and the bowling event broke all records in the number of pledges and money raised.

SAFER SEX POSTERS

DESIGN STUDIO: After Hours Creative, Phoenix, AZ
ART DIRECTION: After Hours Creative
DESIGN: After Hours Creative
COPYWRITING: After Hours Creative
PHOTOGRAPHY: Bruce Racine, After Hours Creative

In creating a series of posters and condom packaging for the Phoenix-based Gay Men's Sex Project, After Hours used two types of research to determine how best to communicate information on safe sex to men who have sex with other men. They first surveyed, by mail and in person, hundreds of men who have sex with men. The surveys covered issues such as current safer sex practices, where the men get information on safer sex and the extent of their knowledge on HIV and other topics.

When the initial creative direction was presented to the client, there was concern by one of the approval committees that the message of the posters was not clear.

To help determine whether or not this was the case, additional research in the form of one-on-one interviews was conducted. More than one hundred men were interviewed and shown the posters. Their responses confirmed the overall creative direction and the use of highly suggestive, even explicit imagery, coupled with messages that are positive and supportive.

The posters and condom packages are only a part of a large, integrated set of safer sex education and self-esteem building initiatives of the Gay Men's Sex Project. They fit into the program because they work at a grassroots level where men who have sex with men are actually socializing and conducting their lives. The client has reported that the posters and condom packages have elicited extremely positive responses. They've started selling the posters because they're so popular and attendance to educational programs has increased.

GAY MEN'S SEX PROJECT

WHEN HE ABSOLUTELY POSITIVELY HAS TO BE THERE OVERNIGHT

DELIVER

IF HE'S GOING TO STAY THE NIGHT, MAKE SURE HE DELIVERS IN THE RIGHT PACKAGE. FIND OUT HOW SAFE SEX AND GREAT DATES CAN GO TOGETHER. CALL 265-4677 FOR FREE INFORMATION ON GREAT, IT'S A DATE WORKSHOPS.

EXPLORING SEXUAL WAYS TO LIVE.

RETAIL &
ENVIRONMENTAL DESIGN

In the overall marketing system for goods and services, retailers are a primary source for communicating with and selling to the consumer. The image they exude, the service they provide and the shopping experience they offer can dramatically affect the public's reception to and interest in a product or service.

Changes in the way people shop are forcing retailers to restyle their retail environments. Technology has made shopping from the home or office convenient and simple. Home shopping networks are already popular, and it won't be long before consumers regularly order groceries via their computers.

For the general retailer, that means they have to come up with ways to get consumers back into stores. Many are trying to tout shopping as an 'experience' or entertainment event. They sponsor hourly price give-aways or bring in live entertainment. In-store video displays that advertise a product or service are becoming more and more common as retailers seek to educate and interact with consumers. Nike Town in Chicago, for example, is set up like a museum with sports-related exhibits and elaborate displays.

In their book *Retailing*, authors Patrick Dunne, Robert Lusch and Myron Gable explain that the success of a marketing program for a product or service that's sold through retail outlets relies largely on the retailer's image and sales productivity potential. The elements that contribute to image and productivity are store planning (its layout and space allocation), store design (its ambiance and decor), merchandising (the display of merchandise) and visual communications (its identity program, signage and graphics, and point-of-sale information).

Although many design studios are involved in store planning, design and merchandising, we'll focus this discussion on visual communications and the store components to which graphic designers contribute most.

THE DESIGNER'S ROLE
IN RETAIL DESIGN

Visual communications might be the strongest advertisement a retailer can use, especially now when many retailers are cutting back on sales associates and relying more on electronic communication. Signs, graphics, product information displays and store identity materials are often referred to as the "silent salespeople."

". . . (They) provide shoppers with much-needed information and directions on how to shop the store, evaluate merchandise and make purchases," say the *Retailing* authors. If the graphics don't communicate with the customer, then getting them to buy is made that much more difficult.

The authors suggest that for a visual communication program to be effective in marketing the store and its products or services, it should include the following:

• *Identity:* Retailers must distinguish themselves in a highly competitive market with a distinctive name and identity that reflects what they sell and their image.

• *Institutional signage:* This signage describes the retailer's mission and policies regarding customer service and sales. It's usually located at the store entrance and at service desks.

• *Directional, departmental and category signage:* These graphics help the customer navigate the store. Their role is to entice the customer and engage them in the shopping experience.

• *Point-of-sale signage:* POS signs can be instrumen-

tal in influencing the customer's purchasing decision. It must be informative but not intimidating.

• *Lifestyle graphics:* These graphics normally consist of photographs or images that conjure up emotions in the shopper. If they're powerful enough, they can motivate the customer to buy.

CASE STUDY

Fitch Develops Music Store Prototype
for Blockbuster Entertainment

PROFILE: FITCH INC., WORTHINGTON, OH

ADDITIONAL OFFICES: London, Boston, San Francisco

FOUNDED: Fitch & Company founded in 1975 in London; RichardsonSmith founded in 1960 in Worthington, OH. Two companies merged in 1988.

SERVICES: Product development, communications and environments

EMPLOYEES: More than three hundred, including thirty-five in graphic design and seventeen in research

MAJOR CLIENTS: Blockbuster Entertainment, Wolverine World Wide, Iomega Corp., The Lee Co., Caribou Coffee Company Inc., Harman International, 3M, Thermos, Texas Instruments

Blockbuster Entertainment is one of the largest retailers in the world, with more than 3,500 video rental stores in the United States alone. When Blockbuster decided to expand its retail offering beyond video rentals to include music stores, they came to Worthington, Ohio-based Fitch Inc.

Fitch is an international design consulting group that does work in product development, communications and environments. For the new Blockbuster Music stores, Fitch developed a total store concept including the store design, point-of-contact displays and signs and graphics. Although Blockbuster had

To encourage people to come in and sample the roughly 50,000 titles available, the store was designed around a listening center, which consists of a bank of CD players where a staff person will load any number of selections for the customer.

already aligned itself with various music retailers, including Virgin Megastore, Sound Warehouse, Tracks and others, it wanted its own presence in the music retail business.

"This was a new business for Blockbuster, but they knew they wanted a large-format (more than 15,000-20,000 square feet) retail center," says Matthew Napoleon, a senior vice president with Fitch in its Boston office and senior consultant in Research & Strategy. "Through research that our whole design team participated in, we were able to better define the target market and apply a solid marketing strategy to the design."

RESEARCHING THE MARKET—THE DISCOVERY PROCESS

The design team consisted of architects, store designers, researchers and graphic designers.

Fitch addresses each design project using its "4D" process—discovery, define, design and deliver—in which it works with clients to pinpoint their needs and goals and then builds a strategy that will meet them. "It used to be just design and deliver," says Napoleon, whose background is in retail and communi-

cations design. "You could just design intuitively. But we've had to introduce the discovery and define stages because clients want informed design now. The design has to have longevity and it has to communicate with the end user."

In the discovery phase, team members research and gain a thorough understanding of market conditions, user behavior and customer needs. For the Blockbuster project, Fitch's team spent about two weeks visiting music stores in Europe and the United States. They developed a general profile of the typical music store shopper and observed how consumers shopped, how merchandise was presented and what drew customers into a music store.

Also, in conjunction with an independent research company, Fitch conducted "end-user" focus group testing. Several groups were assembled and participants were asked about their music shopping preferences and how they would design their ideal music store. Napoleon notes that end-user testing is a little different from the traditional focus group testing. "The average person can't really tell you what they want, need or desire, if they haven't been exposed to it. We exposed them to tools and concepts that would help them express this."

Each of the music categories is segmented into an individual zone around the listening center, making it easier for customers to find their selection. The Top 20 section is located in the back of the store so as not to intimidate the over-thirty group.

DEFINING THE AUDIENCE AND WHAT THEY WANT

From the discovery phase, Fitch deduced a number of things about music store design and customers. First, music stores consistently display Top 20 selections at the front of the store, which didn't raise any red flags until the team considered secondary research obtained on the music market. The biggest group of music buyers are those over the age of thirty and these buyers tend to shop in mass market retailers, like Wal-Mart or Kmart, for their music. "For that group of customers, music stores are intimidating and unapproachable and they find the staff relatively unfriendly and not helpful," says Mark Artus, the project leader. "We found that there's a huge amount of pain associated with buying music."

Mall music stores tend to have a rock-and-roll attitude about them, which naturally draws in a certain type of customer who would probably walk in even if the Top 20 selection wasn't up front. That ambiance, however, provokes a negative reaction in the over-thirty customer. They also found, Artus notes, that people are very particular about who they shop next to. "They want to feel safe picking out music in different genres." Consumers also want to be able to sample music, which a lot of retailers are unwilling to go along with for fear of attracting loiterers who just want to listen and not buy.

The team used the information they gathered in the discovery phase to define the solution. The main objective was to create a store that was exciting and inviting, and approachable to all demographics. "We want shoppers to feel comfortable in the space and to create an environment where they can find what they want," Artus says. "We also realized that it was important to get people to listen to the music in the store. If they listen to it, there's a high likelihood that they'll buy it."

DESIGNING THE SOLUTION

Not only the layout of the store, but its ambiance—from the lighting to merchandising displays to graphics—had to seduce the customer into the space. From that point, the team designed the solution based on what they had defined. To encourage people to come in and sample the roughly 50,000 titles available, the store was designed around a listening center, which consists of a bank of CD players where a staff person will load any number of selections for the customer. Each of the music categories—country, classical, R&B, Rock and Top 20—is segmented into an individual zone around the listening center, making it easier for customers to find their selection. The Top 20 section is located in the back of the store so as not to intimidate the over-thirty group.

In addition to the logical and inviting floor plan, Fitch relied heavily on graphics to evoke strong emotional associations between the customer and the music. The interior design of the store—its colors, lighting, textures and so on—evolved from the graphics, the design of which was dramatically influenced by additional focus group testing.

Kian Huat Kuan, the lead graphic designer on the

Different graphic concepts were tested using color copies of images such as these. Snippets of music were played and focus group participants were asked to pick the images that they thought evoked the same mood as the music.

project, came up with about twenty images representing the various categories of music. For example, an image of a flame done in vibrant colors, and another of bright, funky type represented the rock music genre. For the testing, color copies of the images were tacked onto a wall. A snippet of music was played and focus group participants were asked to pick the image they thought evoked the same mood as the music.

From the testing, Kuan developed a graphic concept for each music zone that not only sets the mood for the section but clearly identifies the merchandise. The graphic appears on a 3' x 7' panel identifying the zone, and setting the mood for the section. The R&B graphic uses smoky, bluish colors with a shadowy figure reflected on the exterior wall of a weathered building. The country graphic shows a winding country road with a sunset casting long, lonely shadows across it. The classical graphic, appropriately, shows the image of an angelic bust in softened, sophisticated earth tones and deep red and black. For the rock graphic, designers created an explosion of color and light, reminiscent of a rock concert.

DELIVERING RESULTS

The final phase of the process is delivery, where the product or concept becomes a market reality. Fitch developed the 13,500-square-foot prototype store near Blockbuster's corporate headquarters in Fort Lauderdale, Florida. Blockbuster plans to retrofit all its music stores with the new design.

The new music store concept has met with remarkable success. A Gallup survey commissioned by Blockbuster rated the music store at a 97 percent approval rating, the highest rating ever measured by Gallup for a retail store.

"Our research and involvement in developing the plan for this endeavor was so vitally important," Artus says. "Blockbuster came to us and said this is what we want to do; you tell us the best way to do it. If we hadn't researched this and learned the market, we would have ended up with just a superficial, stylistic solution that would be outdated in a couple years. You have to understand the company's roots, its culture and you have to understand the marketplace."

Each music zone is identified by a mood-setting graphic that appears on a 3' x 7' panel.

PROJECT CREDITS
ART DIRECTION: Mark Artus, Paul Lechleiter
DESIGN: Matthew Napoleon, Paul Lechleiter, Mark Artus, Maribeth Gatchalian, Paul Harlor, Scott Richardson, Beth Dorsey, Kelly Mooney, Alycia Freeman, Kian Huat Kuan, Joanie Hupp, Sandy McKissick

RETAIL & ENVIRONMENTAL DESIGN PROJECTS

TIMBUKTUU COFFEE BAR

DESIGN STUDIO: Sayles Graphic Design, Des Moines, IA
ART DIRECTION: John Sayles
DESIGN: John Sayles
ILLUSTRATION: John Sayles
COPYWRITING: Annie Meacham

In establishing the visual identity and environmental design for the Timbuktuu Coffee Bar in Des Moines, John Sayles of Sayles Graphic Design spent hours at the library researching coffee, its history and its place in today's society. He and his design staff visited various coffee restaurants in Des Moines and other metropolitan areas where they surveyed logos and design concepts. Sayles also sampled many of the menu items that would be served in the restaurant.

Research on the business inspired Sayles to base his design on the earthy and exotic reputation that coffee has. Tribal masks, hieroglyphic-style figures (including the "bean man" icon) and hand-rendered type contribute to the presentation. Everything in Timbuktuu consistently reflects the identity—from the clock to the furnishings to the menus.

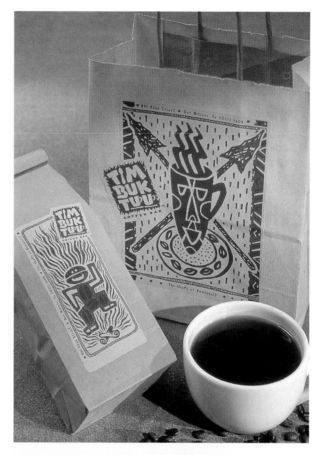

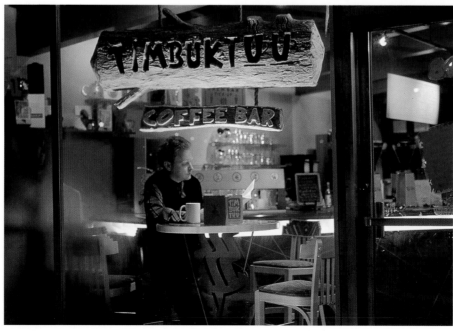

REEBOK
INTERNATIONAL STORE

DESIGN STUDIO: Fitch Inc., Worthington, OH
ART DIRECTION: Beth Dorsey, Matthew Napoleon
DESIGN: Christian Davies, Carol Dean, Kian Huat Kuan, Kelly
 Mooney, Clint Bova, Doug Smith, Randy Miller
ADDITIONAL DESIGN: Category banner, T-shirt classic and dazey
 wheel by C.I.T.E. Design, New York, NY

With this store in the heart of Manhattan in New York City, Reebok's goal was to extend its appeal to a broader group of consumers. Using consumer research gathered by Reebok, Fitch designers set out to emphasize Reebok's core philosophy of encouraging fitness for everyone. This was achieved by designing an environment that offers a high level of accessibility to products, information and service.

The store design is marked by clearly defined sports categories, such as tennis, basketball and aerobics, which help the customer navigate the store. Men's and women's "worlds" were defined in response to research that found men and women generally prefer to shop separately.

The retail environment also offers fun and entertainment. A sports concierge is on hand to answer questions about Reebok's history, its products and local sports events. Sports-specific video monitors and interactive kiosks are placed throughout the facility to encourage interaction between the shopper and the Reebok world.

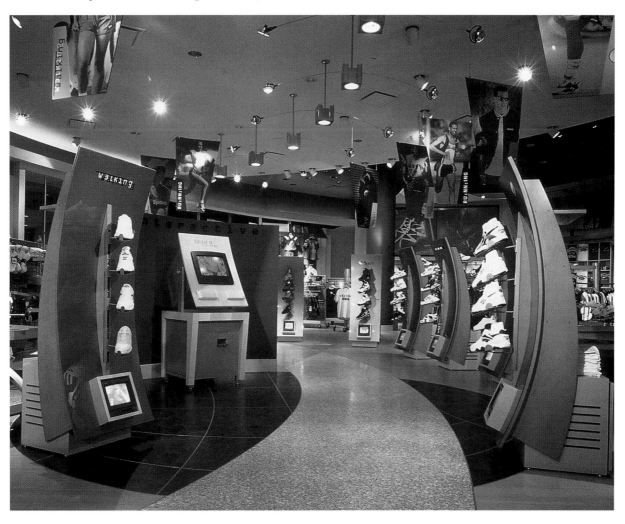

BREW MOON RESTAURANT & MICROBREWERY

DESIGN STUDIO: plus design inc., Boston, MA
CREATIVE DIRECTION: Anita Meyer
DESIGN: Anita Meyer, Jan Baker, Dina Zaccagnini
PRODUCTION MANAGEMENT: Pinpoint Incorporated
ARCHITECTURAL FIRM: Darlow Christ Architects Inc.

In developing an identity for the Brew Moon brew pub in Boston, plus design utilized a vast amount of marketing research information, including focus group testing, comment cards, surveys and a Harvard Business School Field Study. Using this information (which the client has requested remain confidential), plus design developed a comprehensive marketing and design brief that outlined the restaurant and microbrewery's marketing focus; the product concept; a list of words, images, colors and textures related to the concept; a customer profile; and future plans for growing the business.

The design studio's involvement in Brew Moon's marketing program helped the restaurant and microbrewery translate the concept of a generic brew pub into a conceptual, contemporary and whimsical drinking and dining establishment. The design of the Brew Moon name and logo validates the concept. German handcrafted signs served as inspiration for the stenciled portion of the Brew Moon logo,

while the whimsy and romance associated with the moon are reflected in the handwritten moon.

The warm, brew and moon contemporary colors used in the sign system, menus, napkins, uniforms, T-shirts and architecture, help relate the contemporary atmosphere of the restaurant with the quality brewing process and premium beers offered. Little extras set the system apart. For example, drinks are served on thick, absorbent stencil cut-outs that spell out "brew" in aqua, purple and blue moon colors.

The restaurant and microbrewery has been well received by the public and restaurant reviewers. It was featured in an issue of *Bon Appetit* magazine in an article entitled, "Hot Spots—The Top New Restaurants Across the Country." Also, because of all the positive feedback and strong sales, Brew Moon Enterprises plans to open at least ten new restaurants and microbreweries over the next few years.

20

ANNUAL REPORTS

An annual report can be the cornerstone piece in a company's marketing and communications program. For many companies, it is the primary means of communicating with the investment community and the general public. For many investors, it is one of the most important tools they use in making their investment decisions.

Many companies use the annual report as a business development tool in the recruiting process and in developing relationships with vendors, suppliers, partners and customers. As John A. Russell, chief communications officer for Banc One Corp. in Columbus, Ohio, commented in a recent article in *Bank Marketing* magazine: "The annual report is a valuable business development and recruitment tool. It has to position not only the company's financials, but its strategic direction and its corporate culture."

That means that to design an effective presentation, you must understand the company's marketing strategy: the products or services it sells, who the customers are, how that product or service compares to the competition, how it's delivered and how it's promoted. In essence, you must know the client company and its goals as well as you know your own business.

THE CHALLENGE: TWO DISTINCT AUDIENCES

Every publicly traded company is required by law to issue an annual report to shareholders. Because most investors are not actively involved in the operations of the companies they invest in—some might not even know where they are located or what their primary business activities are—they look to the press and the annual report for basic information on a company, such as its history, business philosophy and current performance. An annual report is mailed to all shareholders, usually in the first quarter of the year.

In addition to shareholders, the annual report must address another important audience, the industry analysts who want the nuts-and-bolts, meat-and-bones information on a company's financial standing and operating philosophy. Analysts generally are employed by major financial services and investment firms to study and investigate a certain industry and evaluate the strengths and weaknesses of competitors in that industry. What they write in their reports can dramatically affect the way a company's stock moves.

As a primary communications tool with two distinct audiences, the annual report must be designed and presented in a way that meets the information needs of both. The report normally recaps the company's operations and activities for the year. Financial and balance sheet information is included as is a discussion of the company's plans for the future. Annual reports range in format from simple one-color pieces to glossy four-color books with lots of photos and graphics.

Corporate Reports Tells Magellan's Story in Annual Report

PROFILE: CORPORATE REPORTS INC., ATLANTA, GA

FOUNDED: 1985, by Jim Furbish

EMPLOYEES: Twenty, including four senior art directors, a junior designer, three computer graphics artists, two production managers, four account reps, a creative director, a proofreader and administrative staff

SERVICES: Communications and marketing design, with about 70 percent of work in annual reports

MAJOR CLIENTS: UPS, BellSouth, Turner Broadcasting Systems, Inc., Russell Athletics, Georgia-Pacific, Home Depot

Magellan Health Services in Atlanta relies heavily on its annual report to communicate with investors and the general public. Magellan was formed in 1995 when Atlanta-based Charter Medical Corporation bought a majority stake in Green Spring Health Services in Columbia, Maryland. Charter Medical had provided behavioral health care services and Green Spring had provided managed care services for behavioral health care. With the merger, Magellan now provides and manages behavioral health care services on a nationwide basis. It is one of the first such companies to operate in the United States.

The primary goal of the annual report was to introduce the new company and show investors and industry analysts that the merger would add value to the company's stock.

"We have gone through so many changes and we didn't have a lot of documents to hand out," says Nancy Gore, senior director of Investor Relations and Communications at Magellan. "The annual report was really the only thing we had to showcase ourselves and to illustrate our financial stability." But the challenge was first to educate investors and analysts on the nature of the business.

These preliminary sketches show the development of the "every man" figure that's used extensively in Magellan's final 1995 annual report.

That's where Atlanta-based design firm Corporate Reports Inc. stepped in. Corporate Reports specializes in developing and designing annual reports. The company was founded more than ten years ago and has done annual reports for major corporations including Turner Broadcasting Systems, Inc., The Home Depot, Cox Communications and SouthTrust Corp. They had done Charter Medical's 1994 annual report before its merger with Green Spring.

Gore says that Corporate Reports' role in developing the annual report was one of communications manager rather than graphic designer. "The design really just underscores the message," Gore says. "I would expect the designer of an annual report to have a sense of what Wall Street and the general public is receptive to. They have to understand our business and

industry and how we want to position ourselves in it. The research they do and meetings they have with senior management are crucial in developing the company's message."

KNOWING THE CLIENT'S BUSINESS

The designer's responsibility is not to just decorate pages but to communicate with investors and build their confidence in the company, says Corporate Reports' vice president and design director Brant Day. "Designers often want to be creative and are tempted to come up with really cool designs. But for an annual report, a cool design isn't the client's top requirement. What they care about is investors' perception of their company." In other words, you don't want a

champagne design for a warehouse beer. If investors tend to be the conservative type who are looking for steady, long-term growth, the client is not going to want a groovy design that implicates them as trendsetters or risk takers. "You have to know the market and the mood," Day says.

And that requires a lot of ongoing research. For most annual report projects, Corporate Reports forms a team consisting of an account representative, art director and designer. They gather information on a client company from a variety of resources.

Industry analysts with investment firms, such as Merrill Lynch or Smith Barney Inc., issue reports two to four times a year on the public companies they follow. These reports are made available to the companies, the investment firms' clients, the press, etc.

Corporate Reports usually obtains a copy of analyst reports from their client companies.

"We'll sometimes get fifteen reports on a single company, and they are generated several times a year," says Brooke Fumbanks, vice president of Sales and Account Service for Corporate Reports and account representative for the Magellan project. "These reports are useful in educating us on how the company is perceived by the investor community." A typical report covers trends in the industry, discusses the major competitors in an industry, and each company's strengths and weaknesses. Analysts will also address what, in their opinion, makes the company a strong investment or one that you might want to stay away from. In addition to reading analysts reports, Corporate Reports will occasionally interview the analysts themselves.

A contrast in design between Charter Medical's 1994 annual report and the new 1995 Magellan annual report clearly communicates the company's new direction.

A bright gold cover with the colorful "every man" illustrations makes a bold statement about the strategic merger between the two companies, and Magellan's new ability to offer more diversified services to the market-place and more revenues to stockholders. The cover and first four pages were cut smaller so the letter to shareholders tab was visible immediately to investors. Inside, the word "more," in a variety of typefaces and juxtapositions, is repeated. Arrows that signify movement in a new direction are used throughout.

You have to know if your client's stock hit a new high or a new low, and you've got to be able to understand why.

A third source of information is the client company's management. Before preparing any design of an annual report, an account rep interviews top management—usually four to eight people, including the CEO, CFO, various vice presidents and sometimes a board member.

"Basically, what we're trying to glean from these interviews is what they think makes them a good investment, what sets them apart from the competition, what trends in the industry are they setting or in the forefront of," Fumbanks explains. "Even if we're not writing the copy for the report (which we do in about 50 percent of the cases), we still go through this process." A lot of public companies also have investor relations staff who talk with investors daily about the operations of the company or the performance of its stock. Although you can sense investor perception of a company by the way its stock moves, direct feedback from investors can be valuable information when designing an annual report.

An increasing amount of information on public companies and various industries is available online. More and more companies have developed their own websites. And news organizations, like Dow Jones, provide free information on the stock market and what stocks are experiencing heavy trading.

"This is an ongoing process," Fumbanks says.

"This helps us present the client company with a good third-party reference when we meet with them and explain what we feel needs to be addressed in the communications and marketing materials," Fumbanks says.

ADDITIONAL SOURCES OF INFORMATION

The Corporate Reports team also diligently follows press coverage of the client company and its industry. They regularly read the *Wall Street Journal* and subscribe to a client's community newspapers and to any trade publications or newsletters that cover a client company's industry. Clients will also send newspaper and magazine clippings. Understanding the stock market, and how and why stocks move up or down is very important. You have to be able to read a stock page.

"You can't expect to sit down and learn about an industry and your client's company the day before you're to meet with them to discuss annual report design. For many of our repeat clients, it's a year-long process, scanning various publications looking for any tidbit of information that will help us understand better what they are doing."

PUTTING MARKET RESEARCH TO WORK

Corporate Reports uses the market research it gathers to develop a design directive for the annual report. The directive is basically a summary of where the company is now and where it wants to be, and is based on the conclusions of this research.

"For Magellan," Fumbanks explains, "we realized that analysts needed to be educated first on Magellan's business and then convinced that it was a strong, stable investment. It was clear from the analysts' reports that they did not have a good grasp of what Magellan was trying to do in the merger with Green Spring. They didn't have much to go on because it's essentially a new industry. Plus, the whole health care industry is going through so many changes. Nobody really understood where Magellan fit in the whole scheme." In addition, she says, "We concluded from our interviews with management that the merger meant that the new company could offer more in all areas, and that they wanted to get this story out."

DESIGNING THE ANNUAL REPORT

Working on these conclusions, Day zeroed in on the idea of "more." He cut ties completely with the design of Charter's previous annual reports.

"We wanted a big bang effect. It was apparent to us that we needed to make a strong statement of why the merger had occurred. [The company] had found a way to make Charter a much more solid business and we needed a bold, dramatic design to convey this."

This was achieved with a bright gold-colored cover. The cover and first four pages were cut smaller so that the letter to shareholders tab was visible immediately to investors. Traditionally, this letter is on the opening page of an annual report and many investors expect to see it there. "We wanted to get the story out immediately, though, on those first pages, and tell investors up-front what the new company means to them."

The colorful, modern-looking "every man" illustrations are part of a strong, bold design that signifies the company as being an innovator. The multicolor illustrations represent the company's diverse activities. On the cover, for example, the every man figure is holding the CMC (Charter Medical Corporation) initials. An arrow points to a larger figure holding a compass/globe, which signifies that the merger with Green Spring will facilitate growth and expansion. Another arrow points to the word "more." Large heads and boxed summaries of information and data lend to the direct, decisive mood of the presentation.

Magellan's Gore says the design was instrumental in communicating Magellan's story: A strategic merger created a stronger company that can offer more to the marketplace and more to investors. "Behavioral and psychiatric services is kind of an abstract thing, but we think the design really underscores what we're about. It highlights growth, more revenues, higher stock prices." Gore adds that response to the annual report has been very complimentary. "The analyst from Oppenheimer told me she thought it looked great, told a good story and that it was the best annual she had ever seen."

PROJECT CREDITS
ART DIRECTION: Brant Day
DESIGN: Brant Day
ILLUSTRATION: Brant Day
ACCOUNT REPRESENTATIVE: Brooke Fumbanks

ANNUAL REPORT PROJECTS

BELLSOUTH CORPORATION ANNUAL REPORT

DESIGN STUDIO: Corporate Reports, Inc., Atlanta, GA
ART DIRECTION: Brant Day
DESIGN: Brant Day
PHOTOGRAPHY: Phiilip Vullo

Atlanta-based BellSouth Corporation has more than a million investors and its annual report is a primary means of communicating with them. As a marketing tool, it must maintain the confidence of an investor pool that consists of a significant number of older people. For the design of this annual report, Corporate Reports highlighted the company's record year with lots of four-color photos and easy-to-read financial statements, and tied it in with the impressive things BellSouth was doing for the 1996 Summer Olympic Games.

The design team also used feedback from investor focus groups conducted by BellSouth. The company conducts investor focus groups regularly to monitor investors' thoughts on the company's operations. Part of the focus group discussion is on the design of and information contained in the annual report. Corporate Reports used this feedback to make minor changes to the design of the annual report. For example, focus group participants had responded that the type in the report should be bigger.

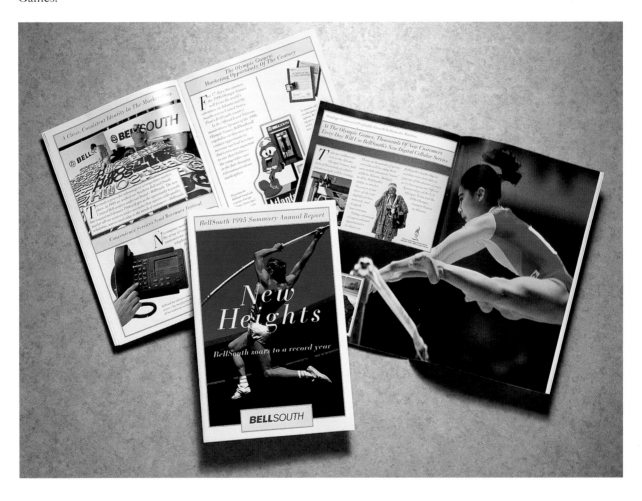

US FACILITIES CORPORATION
ANNUAL REPORT

DESIGN STUDIO: White Design, Long Beach, CA
ART DIRECTION: Jamie Graupner, Thom Page
DESIGN: Jerry Lofquist
COPYWRITING: Josie Velasco, US Facilities Corporation
PHOTOGRAPHY: Jim McHugh

In 1995, Costa Mesa, California-based US Facilities Corporation successfully fought off a hostile takeover by bringing in a new management team. Subsequently, this specialty insurance company experienced one of its most successful years ever. Because the company uses its annual report as the primary means of marketing itself not only to the investment community but also to potential clients, it had to communicate its strategic direction and plans for growth while also detailing its current financial status.

White Design has worked with US Facilities for more than seven years. Account representative and co-creative director Thom Page says he's gained a thorough understanding of the company's business and its industry through regular review of financial reports and analysts' reports. He also meets with senior management of US Facilities to prepare quarterly financial statements that are issued to shareholders.

Page stresses that the design of the annual report is content driven. "We first determine the message the company wants to communicate. Design is a secondary concern." In this case, Page says it was important to let all audiences know that there was new leadership in place. This is achieved through a "down to business" photo of the four management principles that appears on the front cover. Individual full-page photos of each manager then follow on the inside pages, with commentary on the company's goals and direction.

WESCAM INC. ANNUAL REPORT

DESIGN STUDIO: The Riordon Design Group, Inc., Oakville, Ontario, Canada
ART DIRECTION: Ric Riordon
DESIGN: Shirley Riordon
ILLUSTRATION: Dan Wheaton
COPYWRITING: Caroline Glasbey
PHOTOGRAPHY: Peter Emmerson Photography

A series of meetings with senior management and a general understanding of the client's business helped The Riordon Design Group Inc. develop the marketing posture for this annual report—the first for Hamilton, Ontario-based Wescam Inc. since going public in October of 1995.

Wescam uses its annual report primarily to communicate with the investor community. The Riordon design team had developed other key pieces for the company over the years, so was familiar with its business and the direction the company wanted to take. To appeal to investors, both current and potential, Riordon crafted a design that captures Wescam's innovative endeavors into designing, manufacturing and delivering high-value image capture, transmission and interpretation systems to the security, surveillance and entertainment markets. Dramatic photography connotes the quality and speed at which Wescam can transmit information. Additional photos of employees in working situations represent the company's commitment to conscientious, reliable service.

Ric Riordon says that subsequent to the release of the annual report, purchases of the company's stock increased significantly. "Phone calls and positive responses from current shareholders were frequent," Riordon says. "The report enhanced their credibility as a company to be reckoned with in their industry."

MIAMI COUNTY, OHIO ANNUAL REPORT

DESIGN STUDIO: 1•earth GRAPHICS, Troy, OH
ART DIRECTION: Jay Harris
DESIGN: Lisa Harris
ILLUSTRATION: Lisa Harris
PHOTOGRAPHY: Miami County Archives

By Ohio law, counties are required to file an annual report with the state, and make a condensed version of it available to the general public. At the time its 1994 annual report was to be produced, Miami County's courthouse in Troy, Ohio, was undergoing major renovation to repair years of damage caused by weather, old age and lack of maintenance. Millions of dollars were being spent on refinishing the building's great dome, as well as on structural work, painting and other restoration efforts. In fact, the cost of the renovation far exceeded what was paid for the original construction.

Many Miami County citizens were concerned about the amount of money being spent on the courthouse restoration, wondering if the old building was worth the expense. Some taxpayers were openly against the expenditure. Recognizing and understanding public sentiment about the project, 1•earth GRAPHICS set out to show Miami County citizens the value in the restoration project through their design of the condensed annual report. The design team coupled unusual photographic treatments and illustrations of the building's unique features, such as its intricate tile floors, moldings and clock tower, with historical tidbits on the building. Dramatic black and silver duotones accentuate the details and strengthen the photographic impact.

Art director Jay Harris says the response to the annual report was very positive. "It really helped quell fears about the county's expenditure on the renovation. A lot of people even commented that it was the best report ever produced by the county."

GLOSSARY

ADVERTISING
Audio and/or visual stimulus or promotion for which an identified marketer pays the owner of a communications outlet to convey its message, usually to a mass market audience.

ANNUAL REPORT
Yearly financial report, usually in glossy, graphically intense magazine format, prepared by publicly owned companies for their stockholders.

BELL-CURVE DISTRIBUTION
Symmetrically shaped, normal distribution of sample averages around the true underlying value of a population.

BRAND
Product or family of products identified by a unique symbol or name that connotes the product's reputation to buyers or potential buyers.

CENSUS
Poll of an entire population; a technique that is not cost effective for most marketing research purposes unless the population is very small.

CONFIDENCE INTERVAL
Same as *Confidence range*.

CONFIDENCE LEVEL
Mathematical measure of probability used in marketing research that states the likelihood a sample response will be within a certain margin of error or confidence range of the true underlying value in the subject population.

CONFIDENCE RANGE
Mathematical measure of accuracy used in marketing research that describes the possible deviation in a sample response from the true underlying value in the subject population.

CONSUMER
Person or organization that uses a product or service, though it is not necessarily the one that paid for it. Normally refers to use of consumer products rather than business or industrial products.

CONSUMER PANEL
A group of consumers who provide opinions and observations, about one or various products and services, on an ongoing basis over a period of time.

CONTROLLED TEST
Market test in which an organization's own personnel places products at selected retail outlets rather than relying on normal distribution channels.

CONVENIENCE SAMPLE
Sample in which units are chosen without conditions or prequalification, as in selecting persons on the street. Not useful for quantitative studies but a good way to get a quick-and-easy reaction.

CUSTOM RESEARCH DATA
Data derived from a marketing research project that is designed and conducted for a specific purpose, usually by an outside research firm.

CUSTOMER
Person or organization that buys a product or service, generally either for its own consumption or for resale to an end user.

DATA
Elementary facts that, when organized and correlated, provide information from which marketing managers derive market intelligence and on which they base decisions.

DATABASE
System for storing, compiling and organizing data.

DEMOGRAPHICS
Quantifiable market characteristics derived from factors such as age, sex, marital status, income and family size of people or households within the population.

DIGITAL PROMOTIONS
Promotions that employ digital technology via the Internet, CD-ROMs or stand-alone devices to reach prospective buyers.

DIRECT MAIL
Marketing tool that uses promotional materials delivered directly to a targeted audience, usually identified by a carefully compiled mailing list.

ELASTICITY OF DEMAND
Degree to which buyers' willingness to purchase a product is affected by changes in price. Products are highly elastic when small changes in price tend to have a relatively large impact on demand.

EQUILIBRIUM PRICE
Economists' term for the price at which market supply and demand curves intersect.

EXPERIMENTAL STUDY
Marketing research study that compares data from two or more groups of respondents that are differentiated by a key variable, such as groups who use different versions of a test product.

EXTERNAL DATA
Marketing research data obtained from persons and other sources outside the organization.

FIXED COSTS
Expenses incurred by an organization regardless of the level or volume of its output.

FOCUS GROUP
Small collection of people, typically from five to ten in number, guided by a trained moderator whose job it is to elicit opinions about products or concepts. Used by researchers to garner qualitative information but not appropriate for quantitative studies.

FOUR PS
A traditional view of the marketing mix as encompassing the product (or service), price, promotions and distribution channels (place).

FRANCHISING
Operation of multiple businesses under a common trade name by separate owners under contractual obligation to a central franchise holder who owns the trade name.

INFORMATION
Data organized for some useful purpose.

INSIDE-OUT MARKETING
Production-oriented approach to business that focuses on the internal capabilities of the organization itself rather than the needs and desires of customers and consumers.

INTELLIGENCE
Applied *information*.

INTERCEPT STUDY
Marketing research project that collects data from respondents selected on the spot at a public gathering place, such as a shopping mall.

INTERNAL DATA
Marketing research data obtained from records and persons inside the organization itself.

INTERVIEWER BIAS
Improper influence of an interviewer on respondent answers, whether intentional or unintentional, which can skew survey results.

LIFE CYCLE
See *Product life cycle*.

MARGIN OF ERROR
Same as *Confidence range*.

MARKET ENTRY BARRIER
Any of a wide variety of factors that tend to exclude new competitors from a market or make it expensive for them to gain a foothold, thereby protecting established suppliers and allowing them to maintain higher profit margins.

MARKET NICHE
A relatively small market segment or part of a market segment with a strong distinguishing characteristic that is thought to have a significant affect on consumer behavior.

MARKET SEGMENT
Portion of a market distinguished by an identifiable characteristic that is thought to have a significant affect on consumer behavior.

MARKET SHARE
Proportion of total sales of a product classification garnered by an individual product within that classification. Measured either as a percentage of dollar volume or unit volume.

MARKETING INFORMATION SYSTEM
Database and support system designed to provide decision makers with standardized marketing information on an ongoing basis.

MARKETING MIX
The combined means of achieving the marketing goal. See *Four Ps*.

MARKETING RESEARCH
In general, the process of identifying, collecting and analyzing information about the marketplace in order to achieve marketing objectives. In a more restricted sense, it refers to processes dedicated to a specific and limited objective, as differentiated from an ongoing marketing information system.

NONPROBABILITY SAMPLE
Nonrandom sample, which produces results that are not, strictly speaking, statistically verifiable but can be highly accurate and cost-effective for marketing research.

NONRESPONSE BIAS
Inaccuracy in survey results caused by the failure of certain sampling units to participate for reasons that skew the results.

OBSERVATION
Method of collecting marketing research data by recording behavior, either through direct personal observation or using various mechanical/electronic devices such as scanners.

OUTSIDE-IN MARKETING
Market-driven approach to business that focuses on the needs and desires of customers and consumers rather than the internal capabilities of the organization itself.

PANEL
Collection of pesons, businesses or households from whom research data is collected multiple times over a period of time.

PERSONAL INTERVIEW
Method of collecting marketing research data by means of face-to-face interviews or in-person questionnaires.

POPULATION
Identifiable group of persons, businesses or households about which marketing information is sought.

POSITIONING
Targeting a product to appeal to a particular price or status level within a market segment.

PRIMARY DATA
Data compiled or correlated for a specific marketing research project or purpose.

PROBABILITY SAMPLE
Randomly drawn sample, which produces results with statistically verifiable accuracy.

PRODUCT LIFE CYCLE
Characteristic stages of development, maturity and decline that products or services go through, which affect their marketing requirements.

PROFIT
Revenue minus expenses and cost of goods sold.

PSYCHOGRAPHICS
Market characteristics that are less objective but theoretically more predictive of consumer behavior than demographics, derived from a combination of psychological tendencies, demographics and lifestyle preferences.

PUBLIC RELATIONS
Nonpaid communication tools—as distinguished from paid *advertising*—that companies use to promote their policies or products.

PUBLICITY
Free exposure obtained in mass media outlets such as TV, newspapers or trade publications. Generally viewed as having more credibility than advertising or public relations, though not necessarily as effective since the company has less control over content.

QUESTIONNAIRE
Sequence of carefully scripted questions to be asked orally or in writing, designed to elicit certain information about respondents' behavior, status, attitudes or beliefs.

RANDOM SAMPLE
Sample in which each unit of a population has an equal chance of being chosen.

RETAIL
Refers to the final stage of distribution, generally involving transfer of goods to end-users.

SALES PROMOTIONS
Various marketing tools—such as brochures, pamphlets, discounts and giveaways—that are targeted to distributors and retailers, as well as coupons and free samples aimed at consumers.

SAMPLE
Representative subset of a population used to estimate characteristics of the entire population with measurable levels of statistical accuracy.

SAMPLING ERROR
Inaccuracy in survey results attributable to the size of the sample. Some inaccuracy is unavoidable in all surveys unless the entire population is included.

SAMPLING FRAME
Reference group within a population from which a representative sample can be drawn. Same as *Target population*.

SCANNERS
Electronic devices that read symbols or bar codes on product labels. Commonly used in retail operations for pricing and inventory tracking. Used by marketing researchers to track product movements.

SECONDARY DATA
Data used for marketing research that was compiled by a third party without specific marketing research purposes in mind.

SELF-ADMINISTERED STUDY
Method of collecting data in which respondents fill out prepared questionnaires on their own initiative, such as at hotels or restaurants.

SIMULATED TEST
Market test procedure that employs a select panel of consumers or users to estimate the likelihood of a product's success in a larger market. Often preferred over traditional test marketing because researchers can more easily limit costs and time.

SINGLE-SOURCE DATA
Type of marketing research that directly correlates purchasing behavior over time with buyers' exposure to promotional efforts and changes in attitudes.

STRATIFIED SAMPLE
A sample in which a predeter-mined number of units (or minimum number) are chosen in each of certain key segments of the population.

SURVEY
The process of obtaining marketing research data by questioning or observing units of a representative sample within a larger target population.

SYNDICATED DATA
Marketing research data collected by a commercial service for resale to a number of organizations, such as television audience data.

TARGET MARKET
Market segment or niche selected as the object of a marketing effort.

TARGET POPULATION
Reference group within a population from which a representative sample can be drawn. Same as *Sampling frame*.

TEST MARKET
Representative market selected for limited-duration test to determine whether a new product or service has reasonable likelihood of success on a larger scale.

TRADE PROMOTIONS
Incentives employed by manufacturers and producers at the wholesale level to encourage distributors, agents and dealers to sell or promote their products. See also *sales promotions*.

VARIABLE COSTS
Incremental expenses incurred by an organization as output or volume increases.

WHOLESALE
Refers to intermediate stage of product distribution chain between manufacturers and retailers.

ADVERTISING (1ST EDITION) by Thomas O'Guinn, Chris Allen and Richard Semenik. ITP South-Western Publishing Co., Cincinnati, OH, 1997.

"ANNUAL REPORTS AS MARKETING TOOLS" by Karen Kabler Holliday. *Bank Marketing* magazine, August 1994, p. 23.

BUILDING YOUR COMPANY'S GOOD NAME by Davis Young. American Management Association, New York, NY, 1996.

CASES IN MARKETING MANAGEMENT by Douglas J. Dalrymple, Leonard J. Parsons and Jean-Pierre Jeannet. John Wiley & Sons, Inc., New York, NY, 1992.

THE DESIGNER'S GUIDE TO CREATING CORPORATE I.D. SYSTEMS by Rose DeNeve. North Light Books, Cincinnati, OH, 1992.

ENTRY BARRIERS AND MARKET ENTRY DECISIONS by Fahri Karakaya and Michael J. Stahl. Quorum Books, New York, NY, 1991.

THE HANDBOOK OF BRAND MANAGEMENT by David Arnold. The Economist Books Limited, 1992. Published in the United States by Addison-Wesley Publishing Co., Reading, MA.

HEARING THE VOICE OF THE MARKET by Vincent P. Barabba and Gerald Zaltman. Harvard Business School Press, Boston, MA, 1991.

THE HISTORY OF MARKETING THOUGHT (3RD EDITION) by Robert Bartels. Publishing Horizons, Inc., Columbus, OH, 1988.

INTRODUCTION TO MARKETING by Marjorie J. Cooper and Charles Madden. HarperCollins Publishers Inc., New York, NY, 1993.

KNOW YOUR MARKET: HOW TO DO LOW-COST MARKET RESEARCH by David B. Frigstad. The Oasis Press/PSI Research, Grants Pass, OR, 1995.

MAIL MARKETER—GROW YOUR BUSINESS USING THE MAIL by Sandra J. Blum and Mary Pretzer. A Pitney Bowes Best Practices Guide (CD-ROM), ActiveBook Technology, 1996.

MANAGEMENT SKILLS IN MARKETING by Stephen Morse. Pfeiffer & Co., San Diego, CA, 1994.

MARKET RESEARCH AND ANALYSIS (2ND EDITION) by Donald R. Lehmann. Richard D. Irwin, Inc., Homewood, IL, 1985.

MARKETING by David Mercer. Blackwell Publishers, Oxford, U.K., 1992.

MARKETING FOR NONMARKETERS by Houston G. Elam and Norton Paley. American Management Association, New York, NY, 1992.

THE MARKETING INFORMATION REVOLUTION by Robert C. Blattberg, Rashi Glazer and John D.C. Little. Harvard Business School Press, Boston, MA, 1994.

MARKETING MANAGEMENT AND ADMINISTRATIVE ACTION by Steuart Henderson Britt, W. Boyd Harper, Jr., Robert T. Davis and Jean-Claude Larreche. McGraw-Hill Book Co., New York, NY, 1983.

MARKETING MASTERS by various. American Marketing Association, Chicago, IL, 1991.

MARKETING MASTERS: LESSONS IN THE ART OF MARKETING by Paul B. Brown. Harper & Row, Publishers, Inc., New York, NY, 1988.

MARKETING MISTAKES by Robert F. Hartley. John Wiley & Sons, Inc., New York, NY, 1992.

MARKETING MYTHS THAT ARE KILLING BUSINESS by Kevin J. Clancy and Robert S. Shulman. McGraw-Hill Inc., New York, NY, 1994.

THE MASTER MARKETER by Christopher Ryan. IdeaWorks Publishing, Inc., Rockville, MD, 1993.

THE MCGRAW-HILL 36-HOUR MARKETING COURSE by Jeffrey L. Seglin. McGraw-Hill Publishing Co., New York, NY, 1990.

MILLION DOLLAR MAILINGS by Denison Hatch. Regnery Gateway, Washington, DC, 1992.

"PACKAGE DESIGN: THE ART OF SELLING, ALL WRAPPED UP" by Ellen Ruppel Shell. *Smithsonian* magazine, April 1996, p. 55.

PRACTICAL MARKETING RESEARCH by Jeffrey L. Pope. American Management Association, New York, NY, 1993.

RETAILING (2ND EDITION) by Patrick Dunne, Robert Lusch and Myron Gable. ITP South-Western Publishing Co., Cincinnati, OH, 1995.

RETHINKING BUSINESS TO BUSINESS MARKETING by Paul Sherlock. The Free Press, New York, NY, 1991.

SIX TIMELESS MARKETING BLUNDERS by William L. Shanklin. Lexington Books, Lexington, MA, 1989.

STATE OF THE ART MARKETING RESEARCH by A.B. Blankenship and George Edward Breen. NTC Business Books, Lincolnwood, IL, 1993.

TARGETED PUBLIC RELATIONS by Robert W. Bly. Henry Holt and Company, Inc., New York, NY, 1993.

CREDITS LISTED ARE IN ADDITION TO THE CREDITS ACCOMPANYING THE ART ON THE PAGE. ALL PIECES WERE USED BY PERMISSION OF THE DESIGN FIRM.

I •EARTH GRAPHICS pp. 85, 106, 137 © 1•earth GRAPHICS.

AFTER HOURS CREATIVE pp. 83, 104, 108-112, 117 © After Hours Creative.

CANARY STUDIOS p. 84 © 1996 Canary Studios.

CORPORATE REPORTS INC. pp. 129-133, 134 © 1996 Corporate Reports Inc.

CURRY DESIGN p. 72 © Curry Design; photography credits: Forest Pure packaging, Mike Lorig.

FITCH INC. pp. 52-53, 61, 71, 119-123, 125 © Fitch Inc.; photography credits: Iomega Corp., Mark Steele, Fitch Inc.; Digital branding, Peter Rice Boston, Fitch Inc.; JBL speakers, Mark Steele, Fitch Inc.; Hush Puppies branding, Mark Steele, Fitch Inc.; Blockbuster stores, Mark Steele, Fitch Inc.; Planet Reebok, Mark Steele, Fitch Inc.

GRETEMAN GROUP pp. 113, 116 © Greteman Group.

HAL APPLE DESIGN pp. 54, 65-70, 92 © Hal Apple Design; photography credits: Hall Apple self-promo piece, Jason Ware; Mead Corporation Academic branding, Jason Ware; Paper Chase Printing, Jason Ware.

HORNALL ANDERSON DESIGN pp. 50, 63, 73, 76-81 © Hornall Anderson Design; photography credits: Jamba Juice, Tom Collicot; Talking Rain packaging, Darrell Peterson; K2 Skis branding, Tom Collicot; Frank Russell sales promo, Tom Collicot.

MASI GRAPHICA p. 87-91, 94, 105 © Masi Graphica.

MIKE QUON DESIGN OFFICE p. 49 © 1996 Mike Quon Design Office.

MIKE SALISBURY COMMUNICATIONS pp. 62, 102-103 © Mike Salisbury Communications.

PINKHAUS pp. 97-101, 114-115 © 1995 Pinkhaus.

PLUS DESIGN INC. pp. 51, 126-127 © plus design inc.

PRIMO ANGELI INC. pp. 56-59 © Primo Angeli Inc.

THE RIORDAN DESIGN GROUP INC. p. 136 © 1995 The Riordan Design Group Inc.; photography credits: Wescam Annual Report, David Graham White.

SAYLES GRAPHIC DESIGN pp. 60, 74, 124 © Sayles Graphic Design; photography credits: Saks packaging, Bill Nellans; Timbuktuu Coffee Bar, Bill Nellans.

SCOTT HULL ASSOCIATES p. 95 © 1996 Scott Hull Associates.

THARP AND DRUMMOND DID IT p. 82 © Tharp and Drummond Did It; photography credits: Estate Label swatchbook, Kelly O'Connor.

WHITE DESIGN INC. pp. 43-48, 135 © White Design Inc.

WILZ DESIGN INC. p. 93 © Wilz Design Inc.